THE
Archive Photographs
SERIES

KENSINGTON

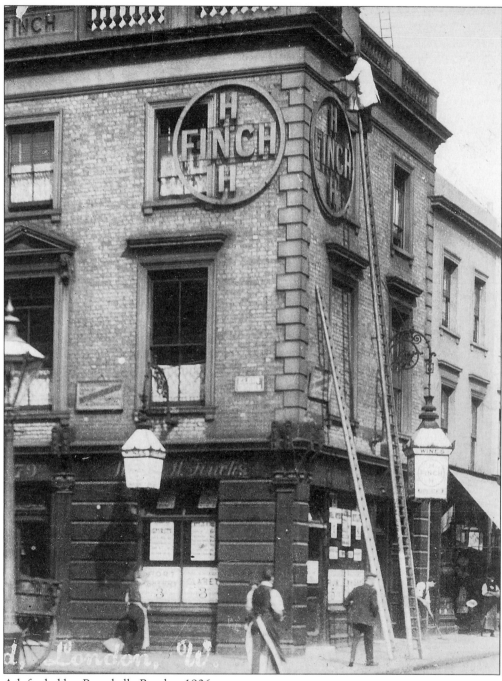

A lofty ladder, Portobello Road, *c.* 1906.

THE
Archive Photographs
SERIES

KENSINGTON

Compiled by
Brian Girling

CHALFORD

First published 1996
Copyright © Brian Girling, 1996

The Chalford Publishing Company
St Mary's Mill, Chalford,
Stroud, Gloucestershire, GL6 8NX

ISBN 0 7524 0369 9

Typesetting and origination by
The Chalford Publishing Company
Printed in Great Britain by
Redwood Books, Trowbridge

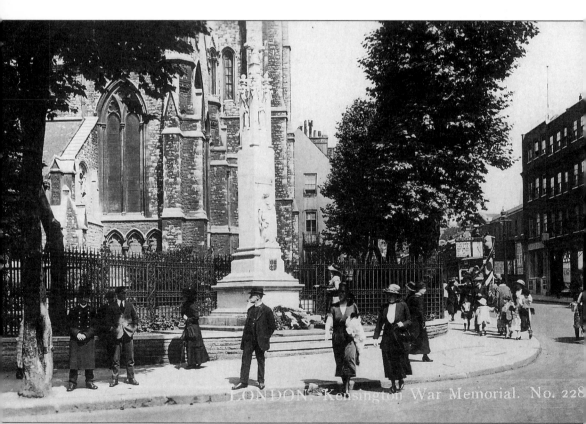

Kensington War Memorial, St Mary Abbots church, *c.* 1922.

Contents

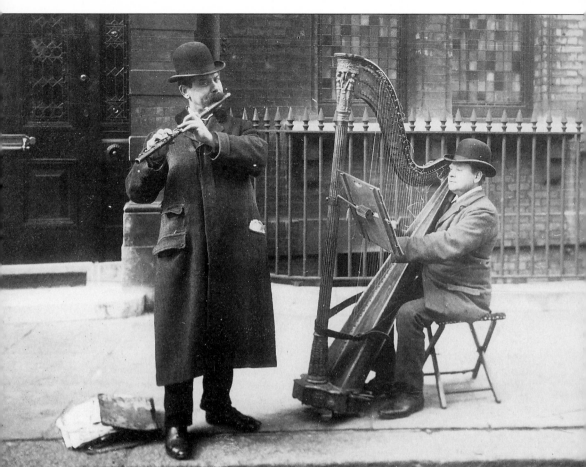

Kensington street musicians, *c*. 1903.

Acknowledgements

For kindly allowing me to include photographs from their collections in this book,
I gratefully acknowledge the help of London Transport Museum,
Ron Elam of *Local Yesterdays* and R.M. Casserley.
Special thanks are also due to
Kensington and Chelsea Local Studies department at the Central Library,
and to Barry Norman and David Brewster.

Introduction

The Royal Borough of Kensington, united by the London Government Act in 1965 with its southern neighbour, Chelsea, to make 'The Royal Borough of Kensington and Chelsea', forms a large slice of inner London to the west of the City of Westminster. Kensington was the larger of the two boroughs and stretched from Knightsbridge, Bayswater and Paddington in the east to the West London Extension Railway to the west and from Harrow Road and Willesden in the north to its southern boundary along Fulham Road.

Contained within those former boundaries are some of London's most distinctive and diverse districts: South Kensington, with its great national museums, cultural centres and fine architecture; Earls Court, with a continuing tradition of spectacular exhibitions and entertainment; Kensington High Street and Brompton Road whose great department stores are famed worldwide. Holland Park is a study in Victorian elegance while Notting Hill Gate's High Street demonstrates the ruthlessness of post-war redevelopment, contrasting with the surrounding streets of pretty, gentrified cottages and grand stucco terraces. North Kensington shows another side of Kensington, where vast areas of poor, crowded accommodation have given way to modern housing schemes, ranging from one of London's most dramatic residential blocks, the thirty-storey Trellick Tower, to newer, leafier low rise neighbourhoods like Wornington Green. Lively street markets and multi-cultural shops give this part of the borough a special appeal. Indeed, it is the variety of shops which enlivens many a Kensington street, where useful domestic stores rub shoulders with an amazing array of exotic restaurants, antique shops, art galleries, up-market boutiques and trendy pubs. The proliferation of pavement cafes in recent years has brought a continental feel to the already cosmopolitan big-city atmosphere of parts of Kensington. The magnificent Kensington Gardens form part of the world famous chain of Royal Parks which run from Bayswater almost to Whitehall and Parliament Square. The greenery that abounds throughout the borough is supplemented by lawns and towering plane trees of the numerous private garden squares, and the street trees, planted in Victorian times, which have grown to maturity for us to enjoy today.

Kensington is now essentially 'inner' London but less than 200 years ago it was all very different. Then, it was a large village in the Middlesex countryside, some miles from the capital city but was then, as now, a fashionable place where people of rank and position lived. They were attracted by the pleasant rural surroundings so close to town, and clean, healthy air, as yet uncontaminated by the emissions of countless Victorian chimney pots. One of the grandest houses was Cope Castle, on which work commenced in 1605 for Sir Walter Cope. This was

eventually renamed Holland House, and another country residence, Nottingham House, also built from 1605, was acquired by King William III, whose poor health necessitated a move away from London's foul air. The house became Kensington Palace and was considerably enlarged by Sir Christopher Wren for King William, who died in 1702. There were further alterations for succeeding monarchs, George I and George II, and various members of the royal family who have continued to live there. Queen Victoria was born at the palace in 1819, and it was her love of her old childhood home that led her to bestow the title of 'Royal Borough' on Kensington. The Great International Exhibition of 1851 set the seal on the development of Kensington, together with the arrival during the 1860s of the underground railways, which speeded the journey to London. The Victorian builders laid out their squares and terraces of grandiose Italianate houses over the old nurseries and market gardens, and modern Kensington was born. There are few traces left of Kensington's Saxon and Medieval origins but the name of Aubrey de Vere, who was granted the manor of Kensington following the Norman Conquest, lives on in several street names.

This book takes us on a photographic tour of the Royal Borough as it appeared some seventy to a hundred years ago, when its gas-lit streets were filled with buildings that might look familiar today but were then crammed with the shops, fashions and street activities of an earlier age. Other views show us scenes that have disappeared without trace, but may well be remembered by Kensington's older residents. The boundaries referred to in the captions are contemporary with the photographs. Photographic reproductions of many of the pictures in this book are available from Brian Girling, 17 Devonshire Road, Harrow, Middlesex, HA1 4LS.

One

Brompton Road and Fulham Road

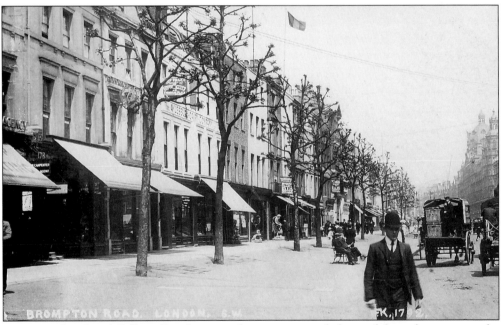

Brompton Road and Fulham Road are two busy commercial thoroughfares that traverse the southern part of Kensington, linking it to the City of Westminster at Knightsbridge and Fulham at Stamford Bridge before running onwards to the River Thames at Putney Bridge. In the earlier part of the nineteenth century when South Kensington, or Brompton as it was then called, was still rural, produce from its extensive gardens was brought to London along Brompton Road. Houses and shops were built along Brompton Road from as early as 1760, when the long terraces we see here were constructed. The photograph, from around 1904, shows a typical Edwardian scene in Brompton Road, its shops fronted by wide-stepped pavements and a narrow carriageway for traffic. Only a handful of these old properties survive today, and the pavements have been eroded to meet the demands of the modern motorist.

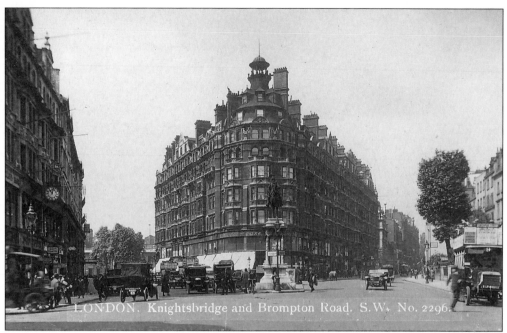

LONDON. Knightsbridge and Brompton Road, S.W. No. 2296.

Brompton Road and Knightsbridge (Scotch Corner), c. 1920. The vast bulk of Park Mansions, built 1900-02, dominates the point where the boroughs of Westminster, Chelsea and Kensington converge. Scotch House, the famous outfitters, occupies part of the retail floors, and there is an arcade of shops between Brompton Road (left) and Knightsbridge. At the left of the picture, the Barclay's bank on the corner of Sloane Street was replaced in 1934 by a new entrance to Knightsbridge underground station. The projecting canopy of the station's former entrance in Brompton Road can be seen in the distance. In the middle of the road is the equestrian statue of Field Marshall Lord Strathairn, cast in metal from guns captured during the Indian Mutiny. The statue was erected in 1895 but subsequently was removed to ease the flow of increasing motor traffic. The stucco-fronted houses on the right were Albert Terrace; their sites were used in the late 1950s for Bowater House and the Edinburgh Gate entrance to Hyde Park. On Park Mansions' frontage stands the Paxton's Head pub, named after Sir Joseph Paxton, whose glass and iron fantasy, Crystal Palace, stood close by, on its original site in Hyde Park. It was built for the Great Exhibition in 1851, the first step towards South Kensington's establishment as an exhibition and museum quarter.

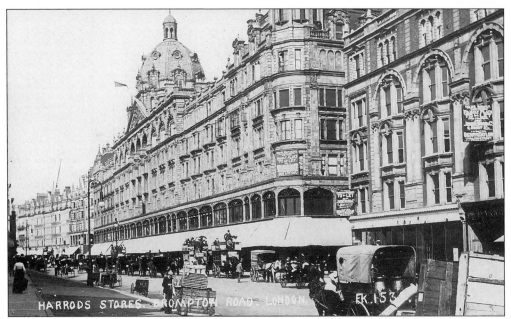

Harrods, *c.* 1904. Now one of the world's most renowned stores, Harrods started life modestly in 1848 when Charles Henry Harrod opened his single grocery shop in what was then a down-at-heel Brompton, Road more noted for Saturday market stalls. Business prospered, adjoining properties were acquired and, in 1902, this vast terracotta palace was built. It originally had residential flats, Hans Mansions, on the upper floors, but these were later incorporated into the store as more retail space was needed. A roof garden and restaurant were added in 1911. The newly built Hans Court is seen to the right of the view.

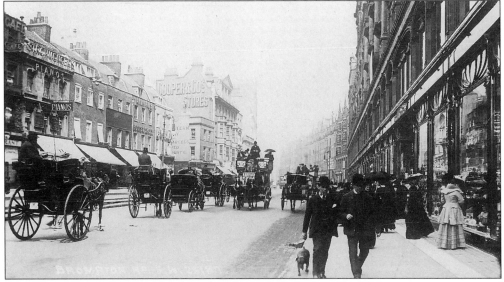

Brompton Road, *c.* 1905. Harrods' famed window displays (right) were an attraction of Edwardian London, as they are today. Opposite were more modest shops, including Strohmenger's piano shop and Ayliffe's shoe shop in an eighteenth-century terrace that was partly demolished for the building in 1934 of Princes Court, a ten-storey block of flats. The traffic was typical of Kensington during the early years of the century.

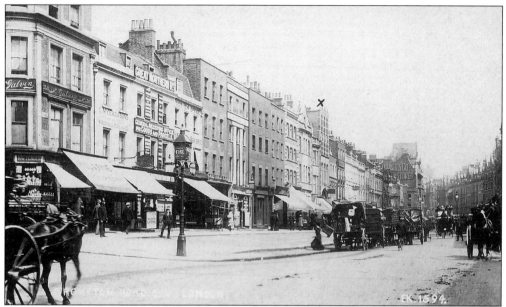

Brompton Road by Montpelier Street, c. 1904. Edwardian Brompton Road was developing into one of London's principal shopping streets, its wide pavements usefully protecting shoppers from muddy splashes from the road. Among a variety of shops in this parade were Edgar Haffenden's, the jewellers, and George Myers, the clothiers. The five buildings nearest the camera still stand. Note the ornate fire station lamp on the Montpelier Street corner denoting the presence of Knightsbridge fire station, then situated in nearby Relton Mews.

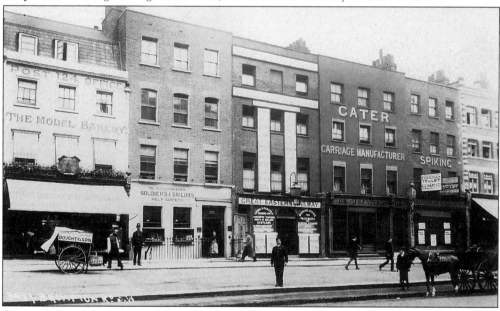

Brompton Road shops in 1904 included that of Doughty & Sons' model bakery and post office, seen on the left with their handcart. Next door were the Soldiers and Sailors Help Society premises, one of the last in Brompton Road to have retained an open basement and railings. The showroom of J.S. Cater, the coachbuilder, reminds us that in 1904 the horse was still used for most road transport.

12

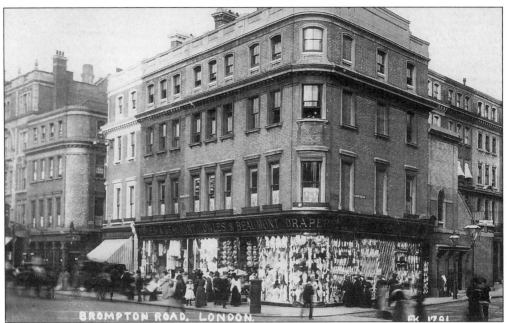

Owles & Beaumont, Brompton Road, *c.* 1904. This popular drapery store flourished through the decades, eventually occupying the whole frontage of the block between Beaufort Gardens and Lloyds Place (later Brompton Place). Note the windows crammed with merchandise, including a fine display of straw hats. The store survived until 1960, when a closing down sale was followed by the demolition of the building. Austin Reed's shop now stands on the site.

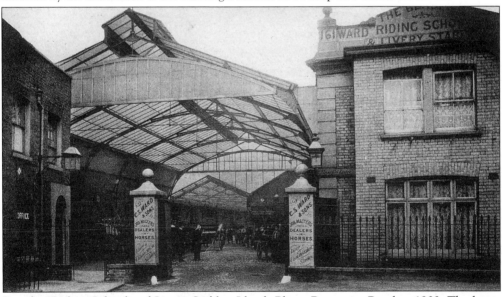

Beaufort Riding School and Livery Stables, Lloyds Place, Brompton Road, *c.* 1903. The horse was king of the road in early Edwardian London and it was as essential to learn the skills of horsemanship then as it is to learn to drive today. C.S. Ward's establishment in Lloyds Place, a cul-de-sac off Brompton Road, would have obliged. Ward's were also horse dealers and 'jobmasters', hirers of horses and carriages. Lloyds Place was renamed Brompton Place during the late 1930s.

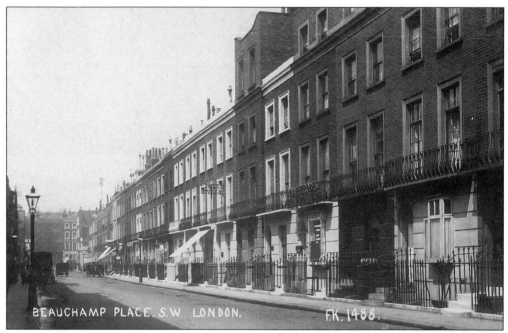

Beauchamp Place, *c.* 1904. Now a street of fashionable and sophisticated shops and restaurants, its Edwardian image was decidedly ordinary with rows of houses and basements. However, the houses were already in multiple occupation by court dressmakers, ladies outfitters, and other small specialist businesses. Beauchamp Place was developed in 1826 and was known as Grove Place until 1885.

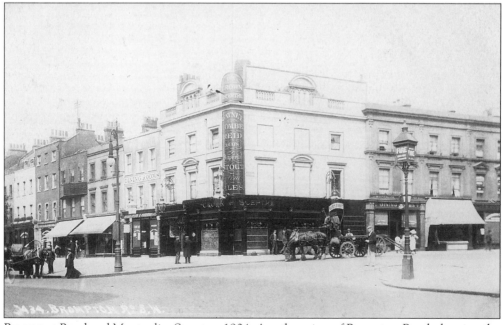

Brompton Road and Montpelier Street, *c.* 1904. Another view of Brompton Road, showing the Crown and Sceptre pub, licencee Max Myers. The pub has recently been replaced by shops, as has the adjoining terrace in Montpelier Street, both rebuilt with replica façades.

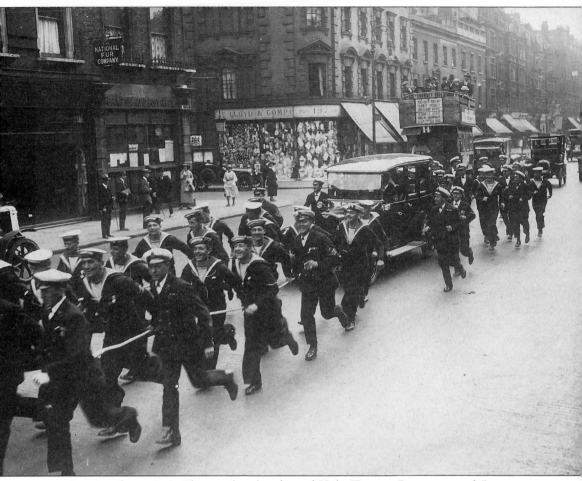

Brompton Road, *c.* 1925. The nearby churches of Holy Trinity, Brompton and Brompton Oratory have long been popular for fashionable weddings, and here we see a rather unusual scene following one of them. The bridal car being drawn at a smart pace by a fine body of naval gentlemen, who are oblivious to the traffic chaos in their wake. In the background, the National Fur Company's shop is seen next to Brompton Road post office on the Ovington Gardens corner. Both premises were eventually occupied by the National Fur Company, whose huge recessed windows became a feature of the road. Further along, E. Lloyd's drapery shops are seen on what became the site of Ovington Court in the 1930s. The Bunch of Grapes pub is the only survivor from these Victorian buildings.

Ennismore Gardens Mews, *c.* 1904. What is now one of London's more attractive mews is seen in its original condition, when horses, carriages and coachmen occupied these premises. Later, as motoring became more popular, the ground floor stables were replaced by garage accommodation for the limousine and the chauffeur resided upstairs in the living area formerly used by the coachmen and their families. This mews once served the wealthy residents of Ennismore Gardens, but now the wealthy also occupy the mews houses, which have been transformed into magnificent homes in an enviable location opposite the gardens of Holy Trinity church.

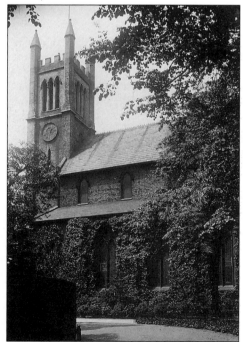

Holy Trinity, Brompton, *c.* 1905. This parish church dates from 1826 and served the residents of what was then Brompton New Town. The church was designed by T.L. Donaldson and, in this attractive study, the bricks are partly covered by the creeper so beloved of the Victorians. The church is approached from Brompton Road through an avenue of lime trees which were planted in 1831.

Brompton Road station, 1971. Although this station had closed on 29 July 1934, the characteristic blood-red tiled frontage was still recognisable nearly forty years later. It opened on 15 December 1906 as a station on the Piccadilly and Brompton Railway (Piccadilly Line), but was rendered redundant by the opening of a Harrods entrance to Knightsbridge station. After many years service as a Territorial Army centre, the old station was demolished in the early 1970s as part of a road widening scheme. Part of the station is still to be found in Cottage Place.

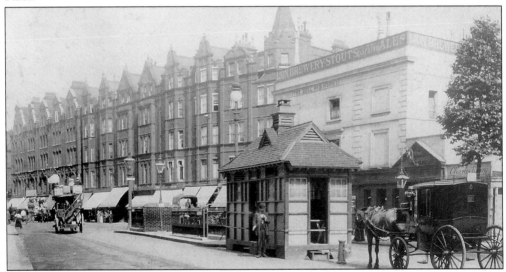

Brompton Road from Thurloe Place, c. 1904. Beyond the cab driver's shelter was the Bell and Horns Tavern, built in 1856 on the site of a much earlier building. Empire House, with its octagonal tower and dome, was built here following the demolition of the pub in 1915. The impressively gabled shops and mansion flats in the background date from 1886.

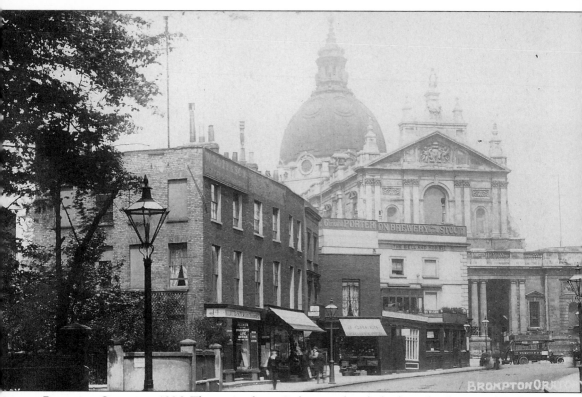

Brompton Oratory, c. 1906. This magnificent Italianate church, built to the designs of Herbert Gribble, dates from 1882, with the dome and façade added later. It replaced an earlier simple building dating from 1854 for the order of secular priests, founded by St Philip Neri in sixteenth-century Italy and were introduced into England by Cardinal Manning in 1847. The interior of the Oratory is opulently appointed and of spectacular dimensions, the nave being one of the widest in England. In the foreground we see the more modest architecture of what was then Fulham Road; but later became part of Brompton Road. The Bell and Horns is seen in front of the Oratory as are a row of shops, once known as Alexander Terrace, including those of J. Green, fruiterer, W. Lott and Sons, builders and the impressively named London, Paris and New York Dress Agency, whose single-storey premises are leaning at an alarming angle. All were swept away for the Empire House development in 1915.

Opposite: Pelham Street from Fulham Road, c. 1906. All the shops and the Pelham Arms pub gave their sites for the Kensington and Knightsbridge Electric Company's new building in 1924. The narrow road was then a busy bus route linking South Kensington with Fulham and Brompton Roads, and this view shows a horse drawn bus preceding one of London's General Omnibus Company's early motor buses.

18

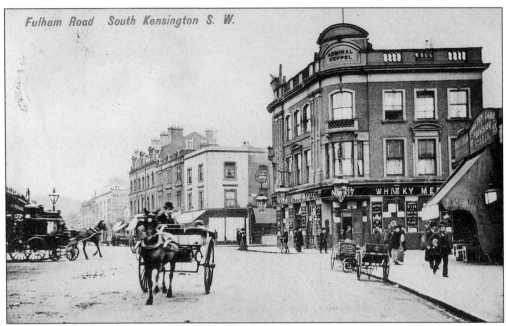

Fulham Road, c. 1906. The most prominent building is the Admiral Keppel pub, built in 1856 on the site of an old country inn and tea gardens. The pub stood on the narrow block between Marlborough Road (now Draycott Avenue), and Keppel Street (now Sloane Avenue), and was demolished during the early 1960s. On the far right the old shops were replaced in 1909 by one of Fulham Road's most noteworthy buildings, the Michelin Tyre headquarters, complete with stained glass and beautiful tile pictures of early motor racing scenes. A carriage is seen emerging from Pelham Street on the left.

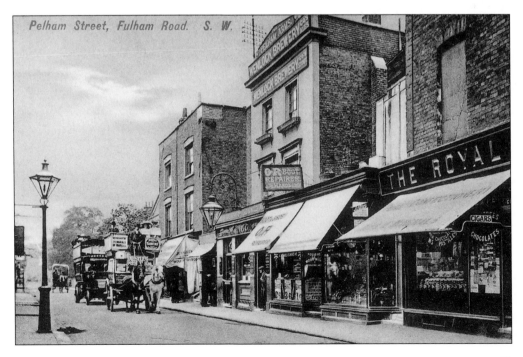

19

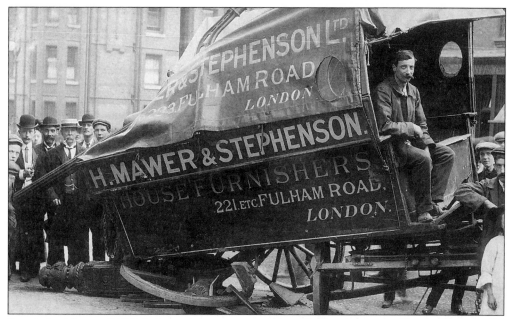

Street Accident, *c.* 1910. It is tempting to assume that the gentler pace of horse-drawn traffic made for safer roads, but as we see here, a heavy furniture wagon and a cast iron lamp-post can produce considerable destruction for the entertainment of the usual collection of loafers that these incidents attract. Messr Mawer and Stephenson, the wagon's owners, occupied a block of six shops on the Chelsea side of Fulham Road opposite Neville Terrace.

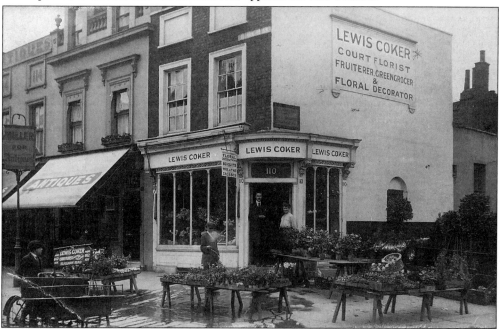

Fulham Road by Selwood Terrace, *c.* 1925. A picturesque corner of old South Kensington, with Lewis Coker's flower shop next to Mrs J.W. Miller's pair of antique shops. This old world row of shops and houses extended as far as Elm Place, but were swept away for the building in 1960 of the tidier but less characterful Regency Terrace.

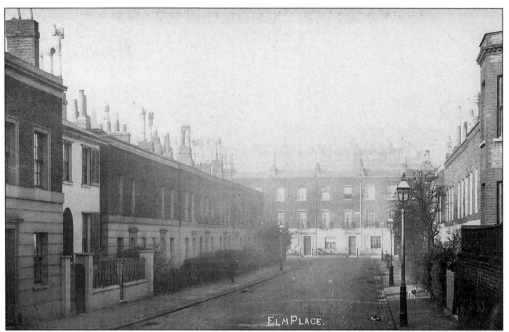

Elm Place from Fulham Road, *c.* 1905. These terraced cottages date from 1830 and have been carefully preserved in a delightful conservation area.

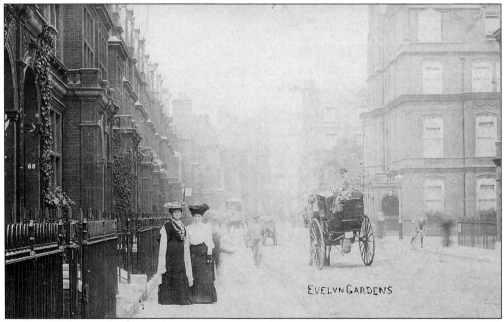

Evelyn Gardens, Fulham Road, *c.* 1905. A few yards west of Elm Place are the grander red-brick houses of Evelyn Gardens, built in 1886. Two ladies in full Edwardian finery pose decorously on the pavement, and we wonder whether it was them or the photographer that caused the hansom cab driver to stop in the middle of the road.

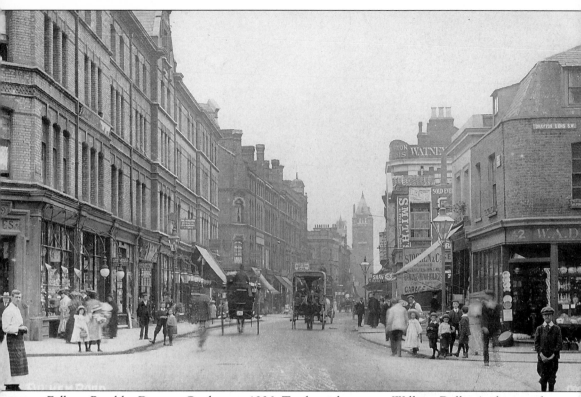

Fulham Road by Drayton Gardens, *c.* 1906. To the right we see William Dolling's china and glass shop, and the premises of Stocken & Co., 'Carriage and Motor Builders to King Edward VII and the Prince of Wales'. All was eventually demolished and the sites used for the Forum Cinema which opened on 18 December 1930. This fine building, later the 'ABC', was designed by J. Stanley Beard, and featured a noteworthy auditorium originally roofed in red fabric to give the effect of an exotic tent. The street lamps give visible evidence that Fulham Road was the boundary between the then separate boroughs of Chelsea and Kensington. The distinctive multi-faced lanterns of Kensington's lamps on the right contrast with the square Chelsea models. The shops on the Chelsea side included Joseph Somes, the pawnbrokers on the corner of Beaufort Street, Charles Smith, grocer and Cooper's stationery shop which included yet another post office. The massive brick tower of St. George's Union Infirmary is in the distance.

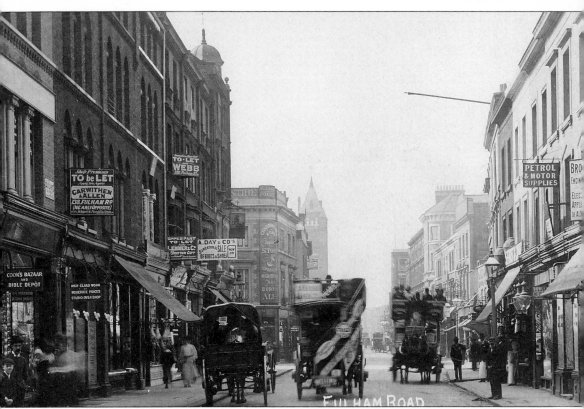

Fulham Road, *c.* 1906. A little further west, Fulham Road remains narrow and congested, as it was when this rare early photograph was taken. It was then full of ordinary shops serving the needs of local residents, among them Farmer Brother's ironmongery store which at the time sold petrol-filling stations were rare in 1906. This photograph, and many others in this book, originated from the shop on the far left, Cook's Bazaar and Bible Depot. Edwin Cook, the proprietor, was an excellent photographer, and much of his work has passed down to us in the form of his huge output of picture postcards of local scenes, some of which can be seen in a display outside the shop. He also had a portrait studio upstairs, but the business seems to have declined towards the end of the decade, for no examples of Cook's work have been found that can be dated after 1910.

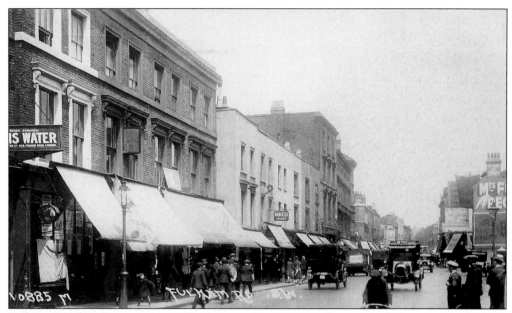

Fulham Road looking east, c. 1930. A musical septet in trilbies and cloth caps march along Fulham Road past a child on the pavement who appears to have been caught throwing something. The roadway is wider here giving prominence to the end wall of the narrow section in the distance, where the large pointing hand and outsize lettering indicated the presence of Mrs Annie Flack's employment agency for domestic servants.

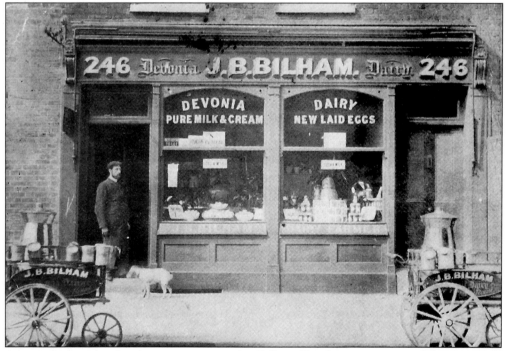

A typical example of a domestic store in the Fulham Road now more noted for its trendy restaurants and specialist shops. This was the splendidly named James Bilham Bilham at the door of his Devonia Dairy at 246 Fulham Road, around 1905.

24

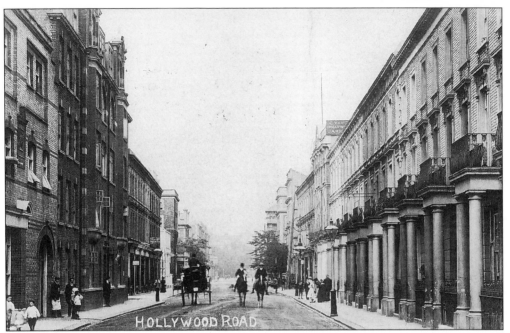

Hollywood Road from Fulham Road, *c.* 1907. Hollywood Road's glamourous name was derived from a distinctly unglamorous brewery that stood here until the houses were laid out during the 1860s.

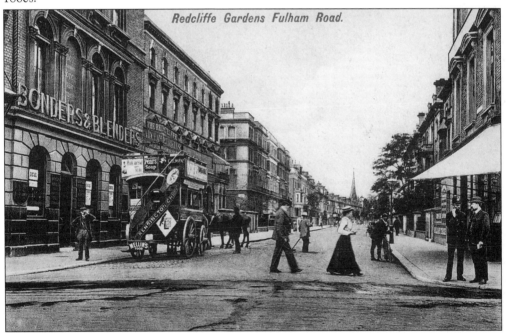

Redcliffe Gardens from Fulham Road, *c.* 1907. A London General Omnibus Company horse-bus stands on the cobblestones of the terminus by the Redcliffe Arms before setting out on its next run to 'Kensington Church'. In the foreground, we see that the water cart has passed by. This was an essential service, as the unmade roads of Edwardian London soon turned to dust in dry weather.

St Marks Road, Fulham Road, *c*. 1905. This impressive line of Hansom cabs gave Mr H.B. Fleming of 5a St Marks Road a living early in the century. St Marks Road was one of a group of streets built in 1847 beside the former Kensington canal, most of which survive as an exclusive picturesque backwater known locally as The Billings, following the renaming of the streets during the 1930s. St Marks Road became Billings Road, North Street became Billings Place and South Street took Billings Street as its new name.

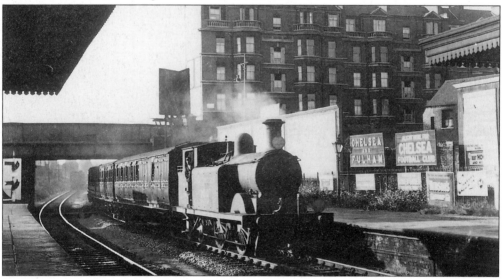

Chelsea and Fulham station, 26 August 1933. The Kensington canal was constructed in 1828, running from the Thames to a barge terminal near Kensington Road and Warwick Road (see page 61). The canal soon became unprofitable, was closed, filled in, and the West London Extension Railway constructed along its former length. Chelsea and Fulham station was built in 1863 near the point where Fulham Road crosses the line at Stamford Bridge, and lasted until 21 October 1940, after which the station remained derelict for many years. Mentone Mansions in Fulham Road are seen here, with the former canalside cottages of The Billings out of sight behind them. (R.M. Casserley Collection).

Two

South Kensington

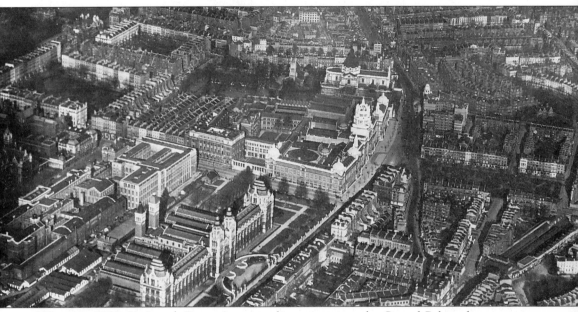

When, in 1851, Sir Joseph Paxton's extraordinary creation, the Crystal Palace, began to rise above the tree tops of Hyde Park, the area to the south of it, Brompton, was for the most part rural in character, with its nurseries, market gardens, and country mansions. The western edge of London's suburban expansion had already began to make its presence felt however, with new squares, terraces and crescents eating into the countryside. Greater changes were imminent following the success of Prince Albert's brainchild, the Great International Exhibition held in the new Crystal Palace. Some of the profits from this unique event went towards the establishment of a quarter for the promotion and exhibition of the arts and sciences, and the first evidence of this came in 1856, when the South Kensington Museum was established at the corner of Exhibition and Cromwell Roads. Although this first effort was an architectural disaster, the magnificent buildings for which South Kensington is renowned soon followed. This aerial view from around 1930 shows the Natural History Museum in the foreground and the Victoria and Albert Museum adjacent to it. Part of the Imperial Institute is seen at the far left, and at the top of the picture, the rectangular site of the Crystal Palace itself is easily found at the edge of Hyde Park. Cromwell and Brompton Roads run through the middle of the view. South Kensington station can be seen on the bottom right alongside the long vanished Onslow Crescent.

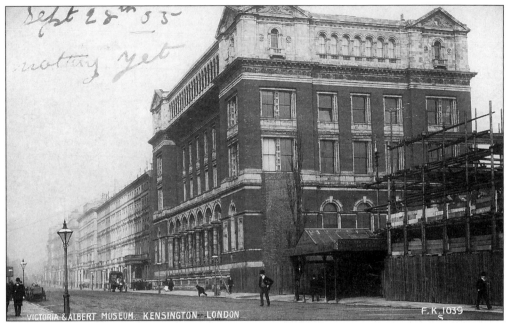

The Royal College of Science, Exhibition Road, *c.* 1904. This magnificent red-brick and terracotta building was designed by Captain Francis Fowke and finished in 1872. It now forms the Henry Cole Wing of the Victoria and Albert Museum, whose formerly ramshackled entrance is seen on the right. The wooden scaffolding obscures part of the vast new V&A, then being built to the designs of Sir Aston Webb.

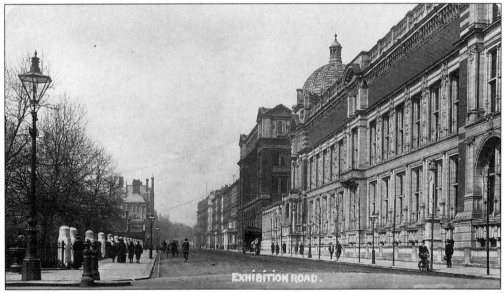

Exhibition Road, *c.* 1908. Part of the new Victoria and Albert Museum has been completed, the bright new stone and brickwork as yet untainted by London's smoky air. During the Second World War, some of the stonework was badly damaged by bomb blasts, and part of it has been preserved with the tablet inscription that it '… is left as a memorial to the enduring values of this museum in a time of conflict'. To the left, the Geological Museum (1935) and the Science Museum (1928) have yet to be built.

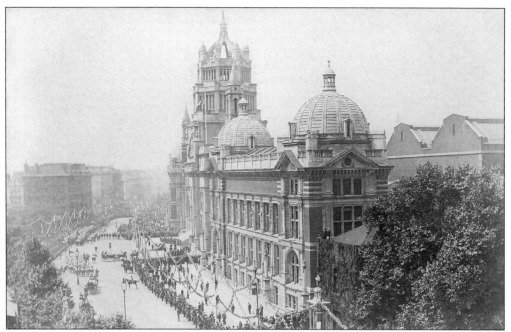

Victoria and Albert Museum, 26 June 1909. A gaily decorated South Kensington welcomes King Edward VII and Queen Alexandra as they arrive to open the new museum. Its magnificence sharply contrasted to its predecessors, buildings so unsightly they became objects of ridicule referred to as ' Brompton Boilers'.

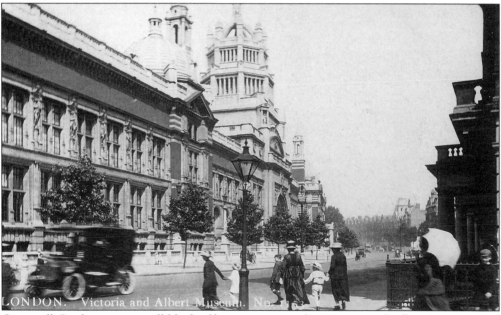

Cromwell Gardens was a small block of houses opposite the Victoria and Albert Museum, and was occupied for many years by L'Institut Francais, the French Institute, until they moved to a new purpose built Lycee in Queensberry Place. The old houses were demolished in 1937, but plans for a National Theatre on the site came to nothing. The Islami Centre, with its polished granite walls, was built here from 1978 to 1983.

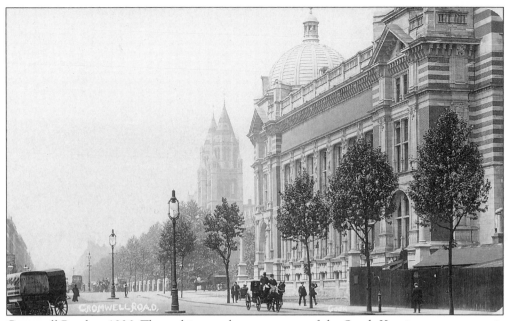

Cromwell Road, *c.* 1906. The architectural extravaganza of the South Kensington museums is continued by the Natural History Museum, seen beyond the partly completed Victoria and Albert Museum.

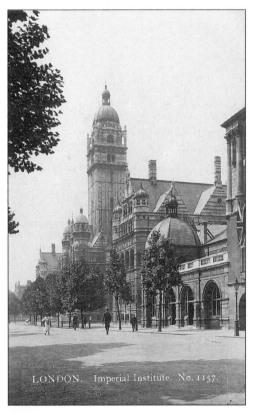

The Imperial Institute, *c.* 1920. One of the finest of the museums was built to the designs of T.E. Collcut, and opened by Queen Victoria on 4 July 1893 as a permanent exhibition of the culture and industries of the British Commonwealth. Tragic demolition in the early 1960s was followed by the opening in 1962 of a new Commonwealth Institute at Holland Park. The great 287 foot central tower with its fine peal of bells was spared to contrast with the uninspiring Imperial College buildings that now surround it. These also replaced the Victoria and Albert Museum's Indian section, with the domed roof, and on the far right, the Royal College of Needlework.

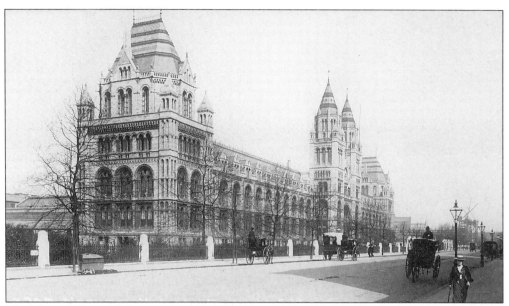

The Natural History Museum, Cromwell Road, *c.* 1903. The British Museum's natural history collections are housed in this Romanesque terracotta fantasy, opened in 1881. The site had previously been used for another international exhibition, that of 1862. This view of the museum is now partly hidden by fully grown plane trees whose saplings are visible here. On the horizon, constructor's cranes beaver away, as the new V&A building takes shape.

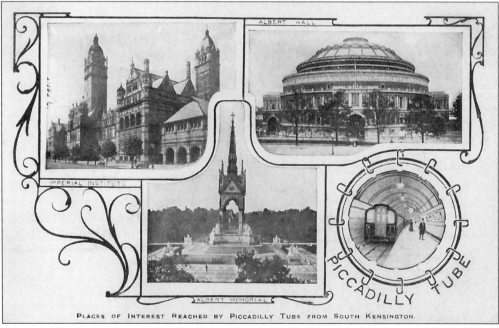

It was once common practice for railway companies to issue attractive sets of postcards depicting places of interest close to their lines in an effort to increase passenger traffic. London's new electric railways were no exception, as this example from around 1908 shows us. The Imperial Institute, Albert Hall, and the Albert Memorial were all easily reached from the new Piccadilly line station at South Kensington, (see page 35).

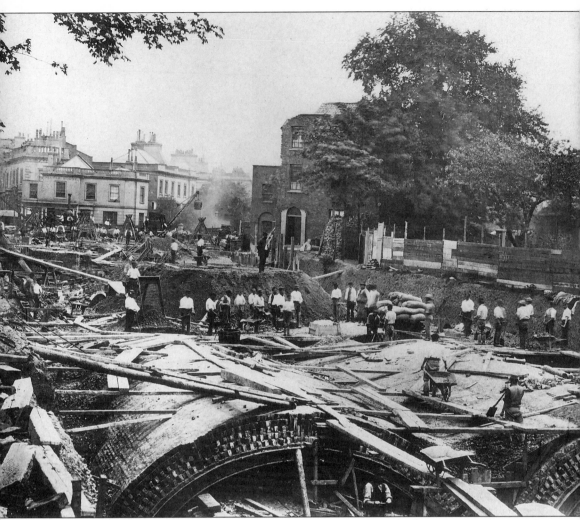

History was made on 10 January 1863 when the Metropolitan Railway Company opened a stretch of railway line between Farringdon Street, to the north of the City of London, to the suburb of Paddington. The new service marked the beginning of the world famous London Underground system, and was the first urban underground passenger railway in the world. The revolutionary subterranean travel proved a success, and soon schemes were afoot to create an 'inner circle' of underground lines to link with existing surface railways. The Metropolitan Railway's new line extended from Edgware Road, reached Gloucester Road via Kensington High Street on 1 October 1868, and South Kensington on 24 December 1868. This photograph shows the scale of the work involved in building the line, with doomed houses on the triangular site in the distance that was to become the new South Kensington Station. These included Pelham House and Pelham Terrace, where Pelham Street now is. The foreground works were covered over upon completion, and Harrington Road laid out above them. (London Transport Museum).

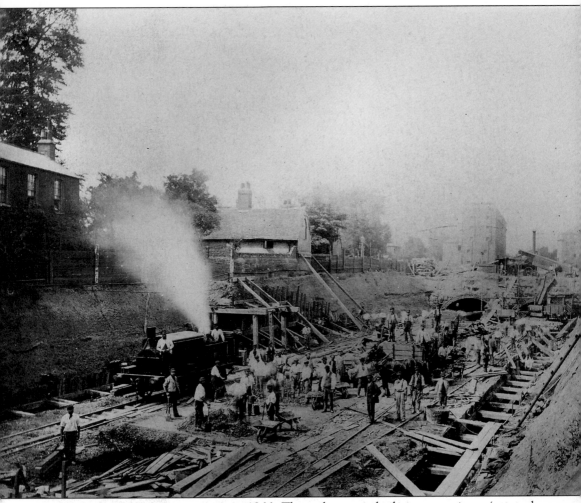

Metropolitan Railway construction, *c.* 1866. The railway was built in part using a 'cut and cover' system that involved the excavation of deep cuttings in which brick tunnels were constructed, and then buried in order that development could proceed above them. This busy scene shows the builder's temporary railway with a steam engine, aptly named *Handy*, used for moving heavier material. To the left can be seen what was then the village of Brompton, but in the distance was the housing development of Stanhope Gardens, whose grandiose proportions became the norm for South Kensington. This view also shows the site of Harrington Road, constructed above the new railway in 1873. (London Transport Museum).

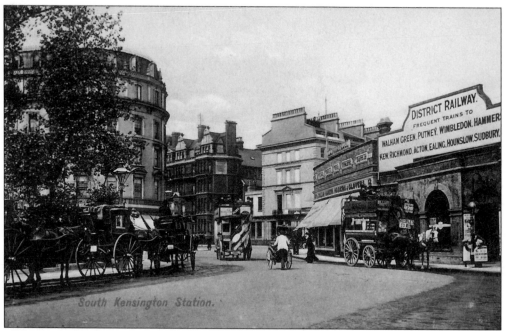

South Kensington station, *c.* 1905. This was the original yellow brick fronted station that lasted until 1907 when the present station and shopping arcade were built. Lapworth and Company, the clothiers, then occupied shops to the left of the station entrance. Harrington Road and the Norfolk Hotel are seen, centre, with the gardens of Onslow Crescent beyond the cab rank to the left.

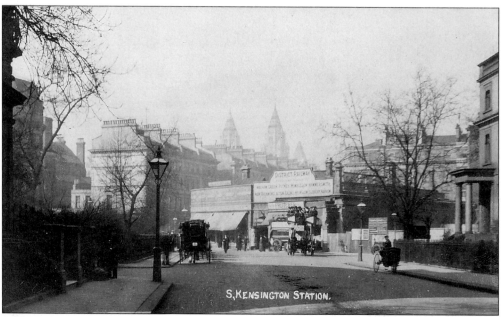

Old South Kensington station, *c.* 1905, with Onslow Crescent (left), and houses on the right where Malvern Court flats were built in 1929. Cromwell Place and the Natural History Museum can be seen in the distance.

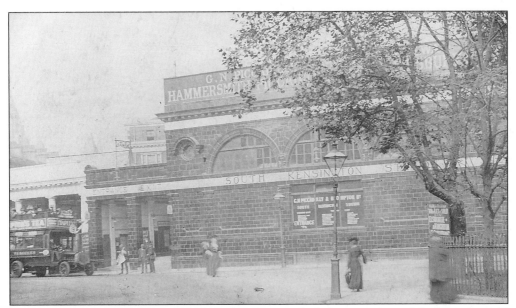

South Kensington station, *c.* 1908. A striking new red-tiled station opened for business on 8 January 1907 to serve the deep level tube trains of the Great Northern and Piccadilly Railway, the Piccadilly Line. The station's new entrance and shopping arcade is seen behind the old Vanguard motor bus working route 9.

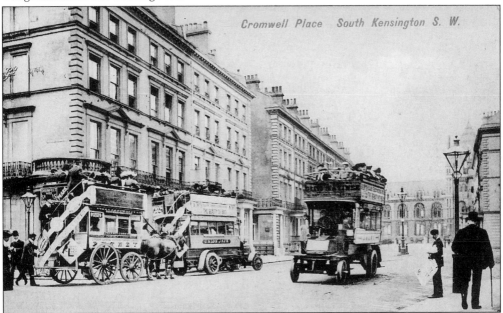

Cromwell Place, *c.* 1906. Old fashioned horse-buses continued to provide a reliable service in Edwardian London while the new motor buses were noisy and often erratic in performance. This photograph shows the vehicles of three separate bus operators: The London Road Car Co., fleet name 'Union Jack'; The London and District Motor Bus Co., fleet name 'Arrow'; and London General Omnibus Co., whose horse bus is seen en route to Liverpool Street from Putney. Although the 'General' bus was the most antiquated, it was this company that was to survive to form the basis of a much more familiar organisation, London Transport.

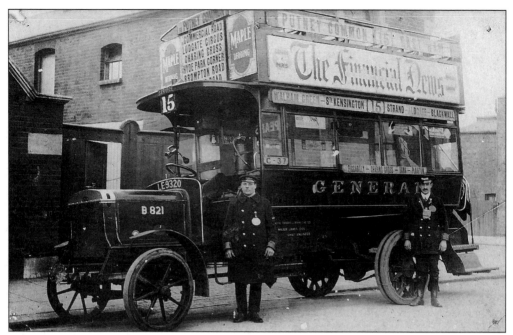

A 'General' bus, *c*. 1912. As the motor bus became more reliable, the old horse buses gradually disappeared, particularly following the introduction in 1911 of London's first mass produced standardised bus, the B type. An example of this is seen here on route 15 which passed through South Kensington from Putney to East Ham.

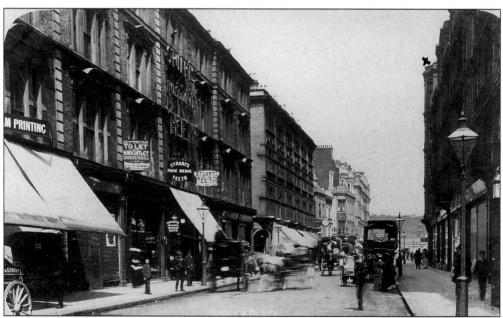

Sussex Place, *c*. 1906. This road ran between Bute Street and Queens Gate, and is more familiar today as Old Brompton Road, the name it acquired in the 1930s. 'Stuart's Prize Medal Teeth' could be obtained at number 12, on the left.

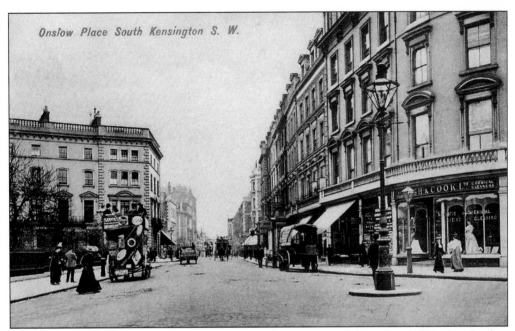

Onslow Place South Kensington S. W.

Onslow Place and Onslow Crescent, *c.* 1906. These two street names are no more; Onslow Place, like Sussex Place is now part of the Old Brompton Road, while Onslow Crescent disappeared in 1937 to be replaced by Melton Court, an impressive block of flats and shops.

Wills and Segar, Onslow Crescent, *c.* 1910. These noted florists once occupied this large conservatory, which stood on the western end of Onslow Crescent. It was pulled down when Onslow Crescent was rebuilt as Melton Court.

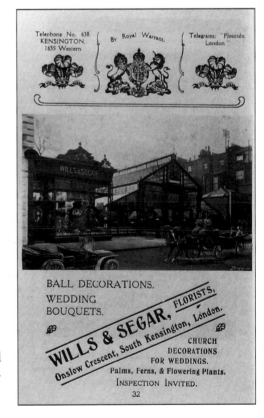

37

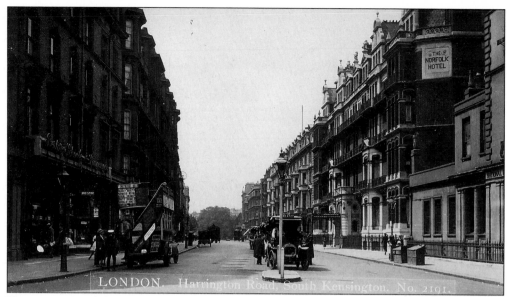

Harrington Road from Cromwell Place, *c.* 1920. A Shepherds Bush bound 49 bus takes on passengers outside the Berlitz language school on the left. Most of these buildings still stand, including the Norfolk Hotel, but the more distant Sussex Chambers were largely destroyed during the Second World War. The street was then paved in tarred wooden blocks which tended to be slippery in wet weather, hence the sand in bins to the right, which was used to improve tyre adhesion.

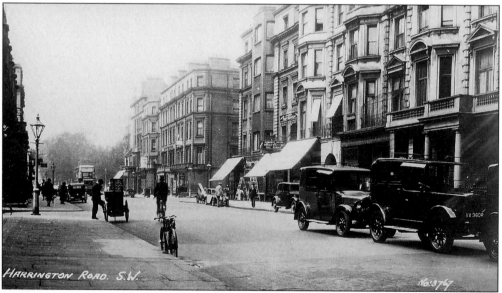

Harrington Road from Bute Street, *c.* 1939. The proximity of the French Institute, by this time in fine new premises in Queensberry Place (centre), was beginning to give this part of Kensington a rather gallic atmosphere, with an increasing number of continental shops and restaurants. This area was devastated in August 1944 by a rocket bomb that destroyed the Naval and Military Hotel (left), and the houses on the right. A new part of the French Institute was built on their sites. Note the street piano by Bute Street. 'Wife and Children to Support, No Pension' – poverty existing along side the affluence of this area.

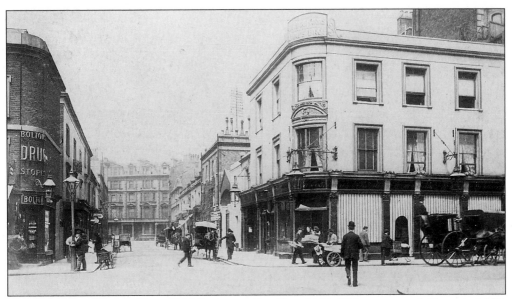

Bute Street from Sussex Place (Old Brompton Road), *c.* 1904. This street was laid out in 1847, its small shops contrasting with later, grander developments nearby. Although most of the old buildings have now gone as a result of war damage and post war renewal, it remains today a street of small exclusive shops. The Zetland Arms still stands on its corner, little changed externally.

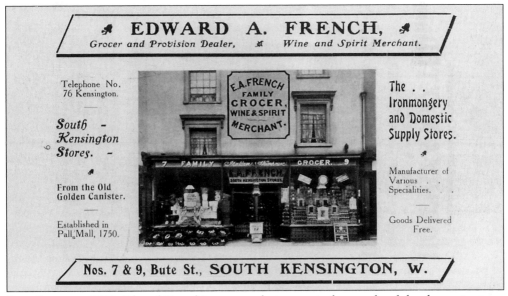

Bute Street, *c.* 1910. Edward French's grocery shop, a typical example of the domestic stores that once abounded here.

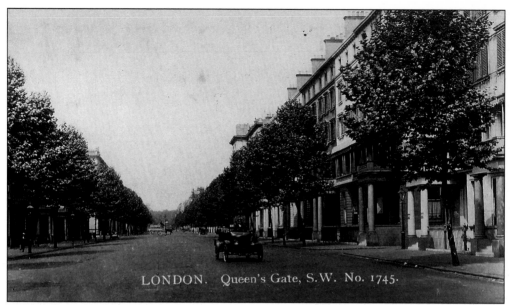

LONDON. Queen's Gate, S.W. No. 1745.

Queens Gate from Harrington Road, c. 1920. This motorist enjoys the enviably traffic free conditions on this 100-foot wide boulevard which runs from Old Brompton Road to Kensington Gardens. Originally named Prince Albert Road, it remains one of the most impressive of Kensington's Victorian thoroughfares despite having its carriageway split by central car parking.

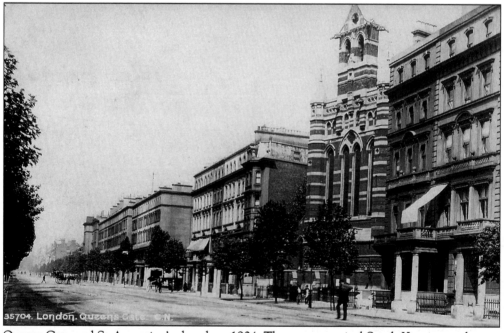

35704. London. Queens Gate

Queens Gate and St Augustine's church, c. 1904. These were typical South Kensington houses with their stucco fronts, porticoes, basements and generously proportioned rooms. St Augustine's church, its facade at an odd angle to the adjacent terraces, was designed by William Butterfield, and was built from 1870 to 1877. Much of Queens Gate was built between 1855 and 1870.

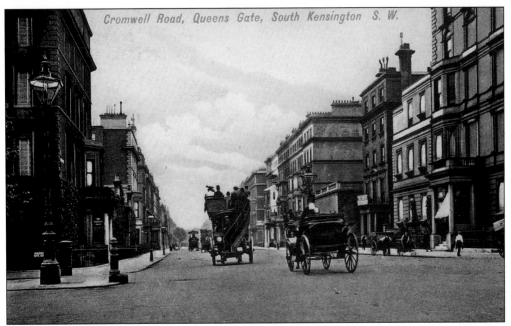

Cromwell Road from Queens Gate, *c.* 1906. The relentless traffic to and from the west thunders through here now, but at the time of this photograph, conditions were far more peaceful. Most of the houses were built between 1862 and 1877.

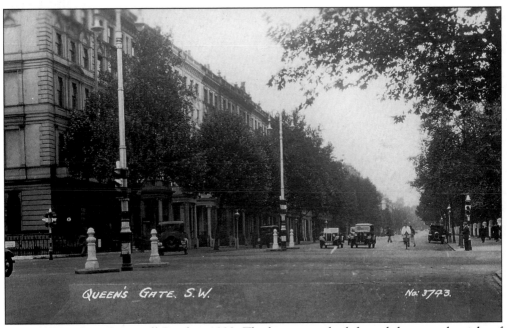

Queens Gate from Cromwell Road, *c.* 1939. The houses on the left, and those on the right of the picture above were destroyed by bombing in 1944, to be replaced in 1961 by Baden Powell House, a hostel for scouts, opened by the Queen on 16 July 1961.

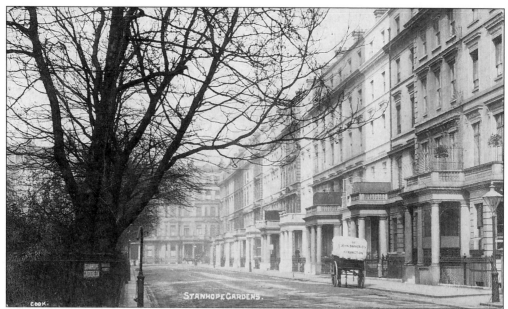

Stanhope Gardens, *c*. 1906. This terrace of Victorian houses, with their mews at the back, was another victim of war-time bombing. The resulting bomb site was left derelict for twenty years until modern houses were eventually built.

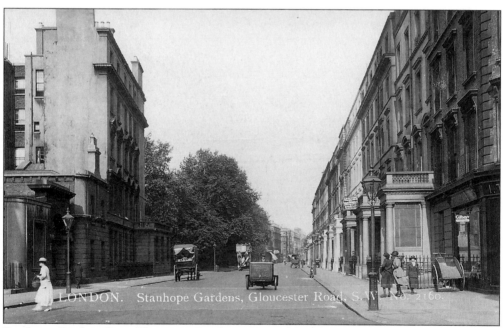

Stanhope Gardens from Gloucester Road, *c*. 1920. Although this photograph is over seventy old, there have been few changes to this scene, the houses in this part of Stanhope Gardens having survived the war. A branch of the well known International Tea Company is seen on the right while, in the road way, an urbane gentleman in a trilby drives an odd looking three wheeled delivery van towards the camera. The entrance to Stanhope Mews West is on the left.

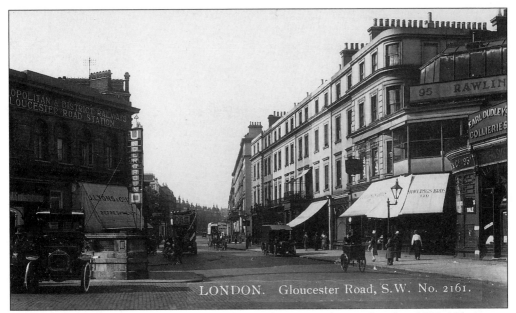

Gloucester Road and station, *c.* 1920. When it first opened on 1 October 1868, 'Gloucester Road Station, Brompton' as it was then called, was the terminus of the Metropolitan Railway's extension from Edgware Road – the line onward to South Kensington was opened a few months later. Although it looks rather sooty in this view, this historic station has been restored to full Victorian splendour, with the light yellow brickwork and green and white mosaic lettering in sparkling condition.

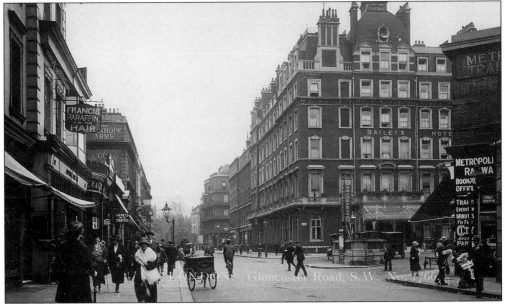

Gloucester Road, *c.* 1920. This road's original name was Hogmire Lane, reflecting its rustic past, which was still evident in 1826 when the name was adopted. This district was for the most part built up in the 1870s, with fine streets like Courtfield Gardens, seen on the right with Bailey's Hotel on the corner. Some ladies parade the fashions of the early 1920s on the left outside the Rawling's electrical store and Philip Francis, the hairdressers.

The Hereford Arms, Gloucester Road, by Clareville Street (then Clareville Grove), *c.* 1905. Externally, the pub appears little changed in the ninety years since this photograph was taken, when it seemed to be popular with cab drivers. The licencee at that time was Mrs Elia Offord.

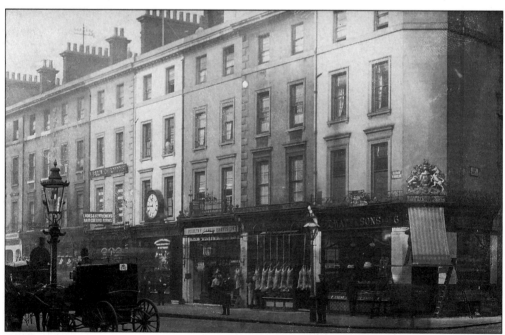

Gledhow Terrace, *c.* 1906. The name has disappeared but this terrace of shops survives as part of Old Brompton Road. Thomas Watt and Sons, bakers, on the Bina Gardens corner proudly displays their Royal Warrant as 'Bakers to Her Majesty the Queen'. Next door was Arthur Wolsey 'Purveyor of Meat', with a row of carcasses dangling unhygienically in the open air. John Ward's jewellery shop is easily spotted with its large clock.

44

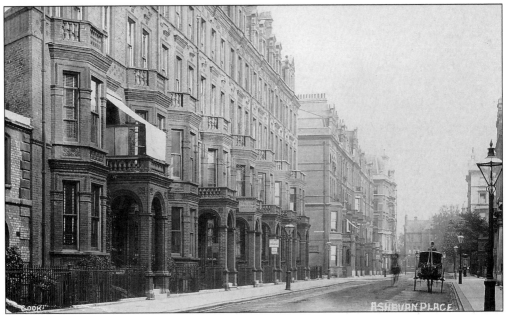

Ashburn Place, c. 1906. The needs of the modern city have transformed this Victorian road in recent years, with the block on the left now occupied by the new Gloucester Park Apartments. The Gloucester Hotel now stands at the distant junction with Courtfield Gardens and to the right, the massive Forum Hotel towers over everything, monuments to the persistent popularity of London as a tourist city.

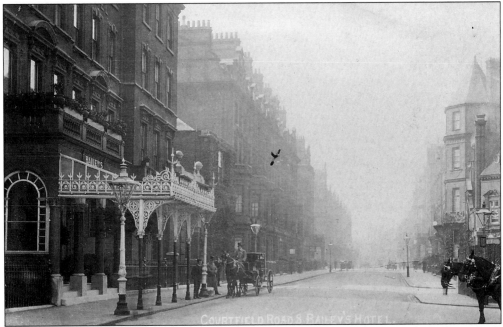

Courtfield Gardens from Gloucester Road, c. 1905. On the left is Bailey's Hotel which was built during the 1870s, now sadly shorn of its fine wrought iron entrance and flanking gas lamps. Beyond, all has now changed with the building of the Gloucester Hotel and the residential apartments behind Gloucester Road station. Ashburn Mews, far right, no longer exists.

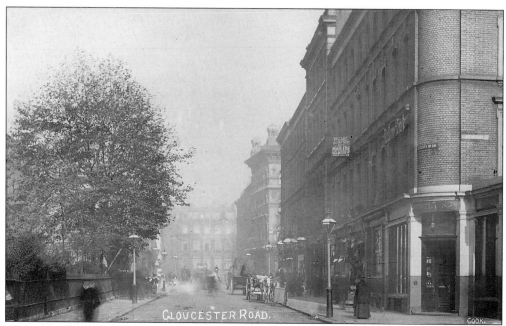

Gloucester Road from Elvaston Place, *c.* 1905. The leafy gardens on the left fronted the long vanished St George's Terrace, rebuilt as St George's Court from 1907-09. The terrace of shops on the right has recently been rebuilt behind the preserved facade.

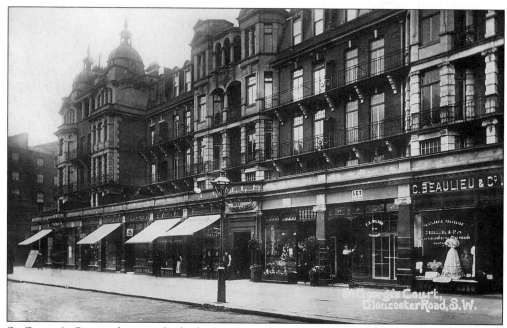

St George's Court, photographed when new, *c.* 1910, its ornate Edwardian style contrasting with the older buildings around it. While most of the shops had been fitted out and occupied, others remained empty. An extremely elegant dress appears on display in the window of C. Beaulieu, the French cleaners.

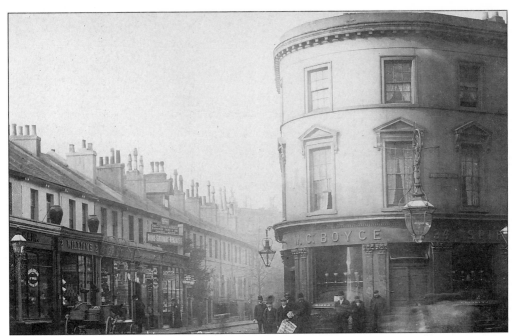

Victoria Grove from Gloucester Road, *c.* 1905. The smaller scale of Kensington's earlier buildings is shown here – these houses and shops formed part of a speculative development of the late 1830s, once known as Kensington New Town. The shops pictured here included a bakery, bootmakers, tobacconists and an oilman.

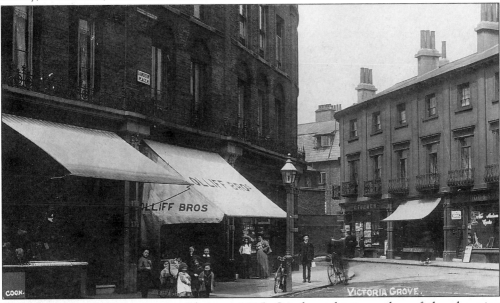

Victoria Grove from Launceston Place, *c.* 1905. On the right is another of the charming terraces that survive from the original Kensington New Town, while the shops on the left, including those of Young and Bennett, wine merchants; Olliff Bros., butchers; and Miss Marianne Dumlin, milliner occupy a building of later date. Until 1905 Launceston Place was called Sussex Villas, and both streets name plates are visible here; that of Sussex Villas, at the top of the picture, is partly obliterated.

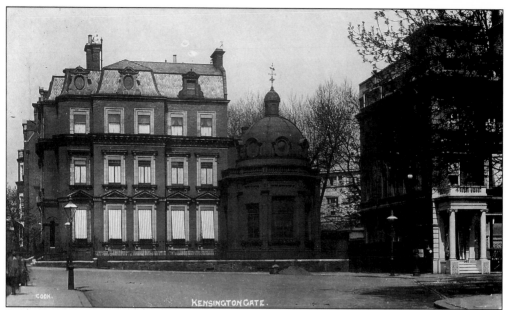

Kensington Gate (right) and Palace Gate (left) from Gloucester Road, *c.* 1906. This impressive mansion, once occupied by the Peruvian Legation, provided the site, in 1938, for what was then a revolutionary construction of reinforced concrete, the block of flats known as 10 Palace Gate. This was designed by Wells Coates, and the building is listed, Grade II. A noteworthy former resident of 2 Palace Gate was artist Sir John Millais (1829-1896), whose famous painting *Bubbles* featured on countless Edwardian picture postcards.

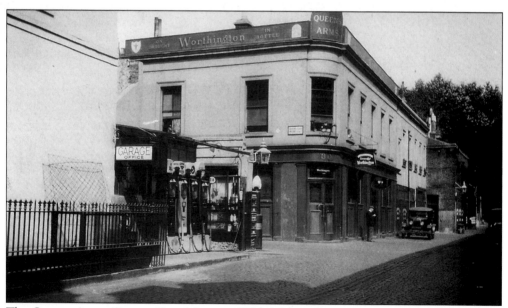

The Queens Arms, Queens Gate Mews, *c.* 1938. Mews pubs are quite rare in London as are mews petrol stations, yet we see the two adjacent here, in what remains a picturesque backwater behind the grand houses of Queens Gate. Celebrated sculptor, Sir Jacob Epstein once had a studio in Queens Gate Mews.

Three
Earls Court

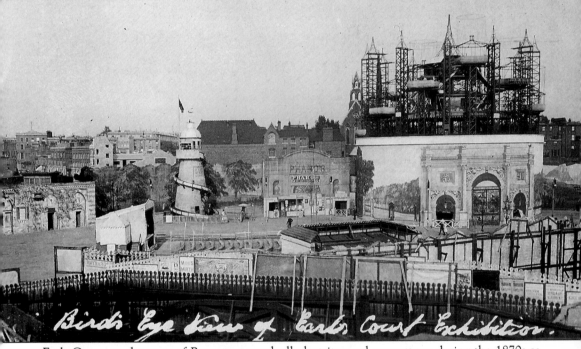

Birds Eye View of Earls Court Exhibition.

Earls Court, to the west of Brompton, gradually lost its rural appearance during the 1870s as new streets were laid out on former farm land and a station built to serve the District Railway trains that ran through the area. As at Gloucester Road, the new station became a focus for the shopping developments that remain a typically cosmopolitan Kensington mixture, bustling at most hours of the day and night. In 1887, three areas of redundant railway land along Kensington's western boundary were transformed into one of the district's more popular attractions, the Earls Court Exhibition Grounds, with their lakes, gardens, amusements, and a spectacular new exhibition every year. Earls Court's greatest years were from 1895 to 1907, when under the directorship of charismatic impresario Imre Kiralfy, the most lavish shows were staged in the Empress Hall. The photograph, taken from near West Kensington station, shows the amusement area including an open air theatre, helter-skelter, and a huge construction where a ride simulated the experience of a balloon ascent. In the background is St Cuthbert's church, Philbeach Gardens and, on the left, the long vanished Fenelon Road (see pages 52 and 60).

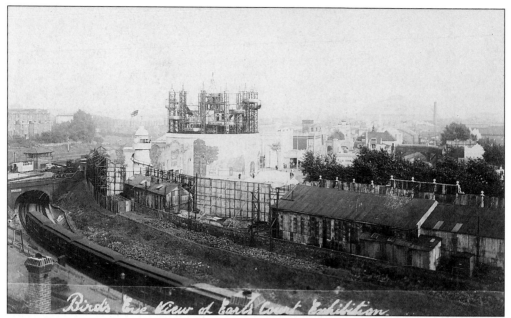

Birds Eye View of Earls Court Exhibition

A rare behind-the-scenes view of the Earls Court Exhibition Grounds in 1907, showing the unsightly sheds that lay behind the glamour of the murals painted on the boundary walls. The Balkan States Exhibition took place in 1907, and featured a village with the distinctive architecture of that region as one of the attractions.

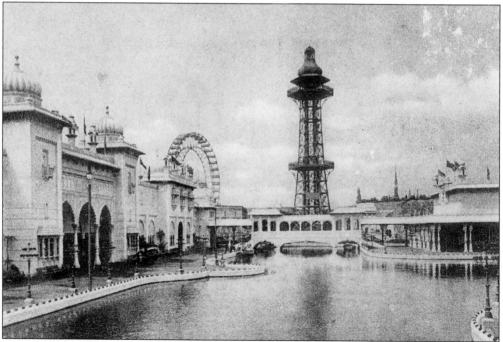

Earls Court Exhibition, *c.* 1898. This was the Queens Court, with its ornamental lake and tower, which could be ascended in an early Otis Elevator. The popular ride, the 'Water Chute', lay behind the camera, and in the distance, the Great Wheel towers over everything. The familiar Earls Court Exhibition Hall, built in 1936, now stands here.

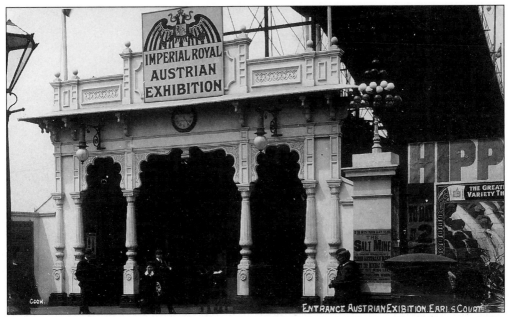

This was the entrance to the Imperial Royal Austrian Exhibition, held at Earls Court in 1906. It featured a Tyrolean village with woodcarvers and lace makers in attendance. In the Western Gardens, the Salt Mine, 'an enchanting reproduction of an Austrian mine' could be viewed, but for those who did not find the prospect of this so enchanting, there was a typical Viennese square complete with 'beer halls'.

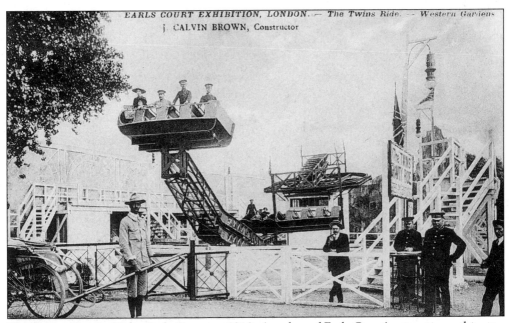

The Twins Gravity Ride, Earls Court, c. 1910. Another of Earls Court's attractions, this one, with safety in mind, had uniformed attendants in each car, although the ride looks rather tame by todays standards. It was designed by J. Calvin Brown, consultant engineer for amusements at Earls Court.

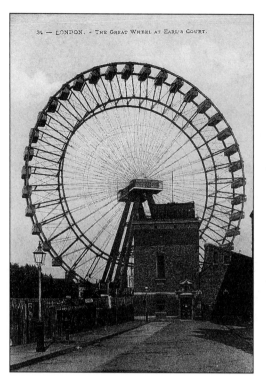

The Great Wheel, Earls Court, *c.* 1905. Earls Court's most spectacular attraction was added to the ground's amusement section in 1894, having been modelled on the great Ferris wheel at the World's Fair in Chicago. 300 feet in diameter, a ride on the wheel took a leisurely twenty minutes in one of the forty seater cabins; ample time to enjoy an unrivalled view of London to the east, and it's Thames-side suburbs to the west. The ride was rather too leisurely on one occasion when the machinery famously jammed for some hours, but the aerial ordeal of the passengers was somewhat assuaged with a compensatory £5 note from the management. This view was taken from Beaumont Road, on the Fulham side of the grounds.

The Great Wheel from Fenelon Road, *c.* 1900, a view that shows how local streets were overshadowed by the immense bulk of the wheel. Fenelon Road was a cul-de-sac whose further progress westward was blocked by the West London Railway lines. The street disappeared at the end of the 1930s, when the Cromwell Road Extension and viaduct were constructed, opening up Cromwell Road as a new London link with the Great West Road.

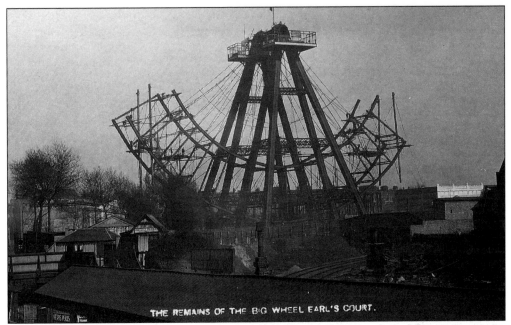

THE REMAINS OF THE BIG WHEEL EARL'S COURT.

Demolition of the Great Wheel, 1907. With the departure of the inspirational Imre Kiralfy for a new venture at the White City, Earls Court gradually declined, the annual exhibitions were less ambitious, and 1907 saw the demolition of the Great Wheel. A view from West Kensington station.

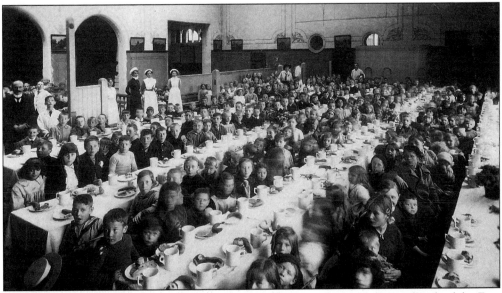

The Refugee Camp, Earls Court, 1914-15. All exhibitions ceased with the outbreak of the First World War, and Earls Court was transformed into a refugee camp for Belgian people displaced by fighting in their homeland. There were many children among them, their education continued in vast classrooms, and at tea time, seen here, 600 of them were accommodated at a sitting. Tea must have been in plentiful supply if the size of the china mug beside each child is anything to go by!

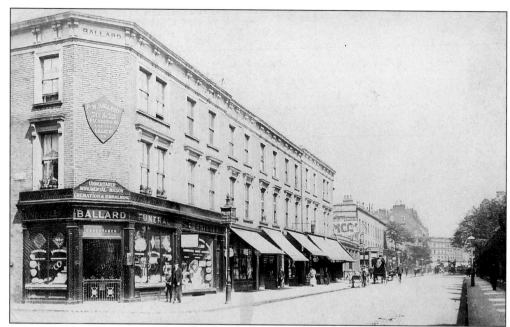

Richmond Road, Earls Court, c. 1906. This was another of the names by which Old Brompton Road was formerly known on its long run between South Kensington and the Fulham boundary at Lillie Bridge. This terrace is of late 1860s vintage, with Ballard's the undertakers on the Kramer Mews corner. Beyond is Warwick Road and a row of shops replaced in 1937 by the Redcliffe Close flats. Brompton Cemetery is on the right.

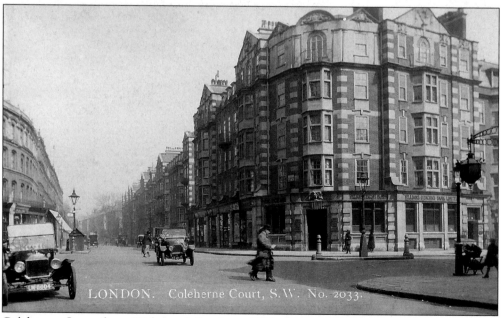

Coleherne Court from Richmond Road, c. 1920. Most of Kensington's later residential developments were in the form of blocks of flats, and Coleherne Court, built from 1901-04 was a typical example.

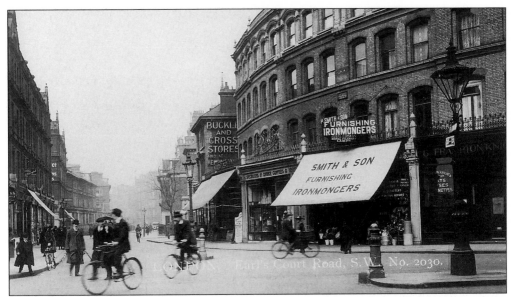

Earls Court Road from Richmond Road (Old Brompton Road), *c.* 1920. A local shopping area at the southern end of this long road, which runs north to Kensington High Street. The well stocked premises of H. Smith & Sons are seen behind their sunblind at Wetherby Terrace (right). Unusually, the bicycle is the only form of transport visible in this street scene.

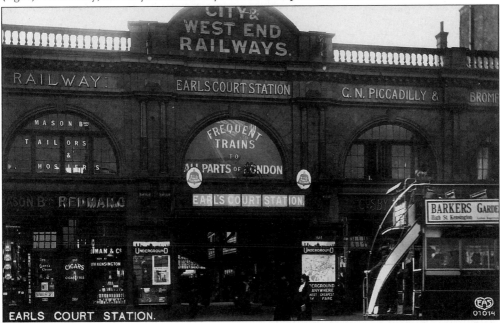

Earls Court station. When it was first opened on 1 February 1878, the station was a plain brick structure replacing an even earlier wooden building which had opened in 30 October 1871. With the arrival here of the new Piccadilly line trains, on 15 December 1906, Earls Court station presented a bright and newly reconstructed face to the world of distinctive golden brown glazed terracotta tiling. A new innovation appeared on 4 October 1911 when escalators were fitted here, the first station on the London Underground to have this facility. Note the old style Underground map which pre-dates the geometric design so familiar today.

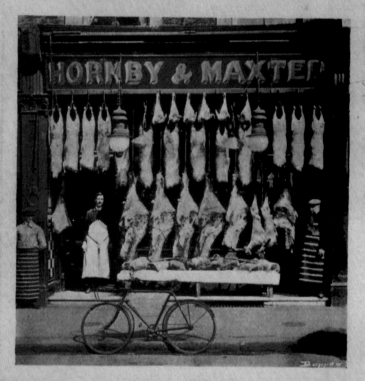

Hornby and Maxted's butchers shop, Earls Court Road, c. 1910. An impressive if unhygienic display at one of the many shops that served the populous Earls Court area.

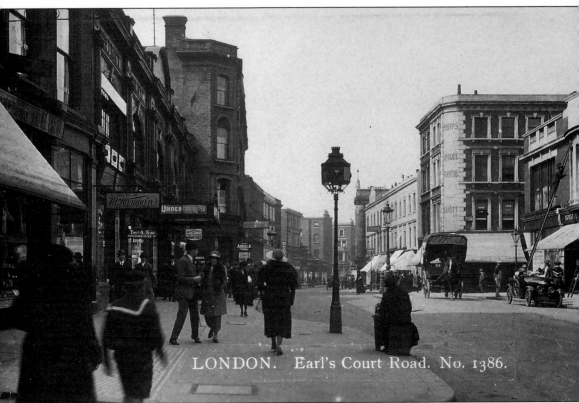

LONDON. Earl's Court Road. No. 1386.

Earls Court Road, looking north, *c.* 1920. Although this view is instantly recognisable, the lack of traffic in what is now an appallingly congested one way system makes it less familiar. This is part of the shopping centre that grew up around Earls Court station, which in its first manifestation as a primitive wooden structure, stood at the right of this view. While road traffic may have been sparse, the pavements were busier in the 1920s, with plenty of well patronised shops, including on the right, the Aerated Bread Company, the familiar 'ABC' of more recent years. A more modest business is seen in operation at the kerbside, as a flower seller displays her stock in a wicker basket. The extravagantly ornate lamp in the centre of the view denotes the presence of a chemist's shop.

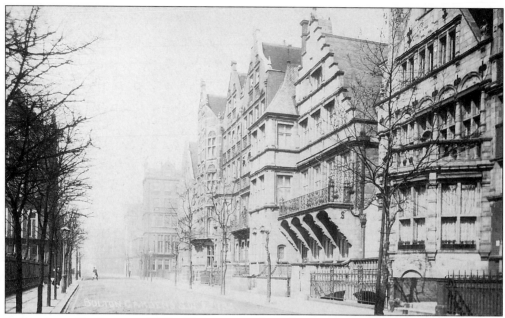

Collingham Gardens, *c.* 1906. The group of roads that include Collingham Gardens, Harrington Gardens and Bolton Gardens contain some of London's most ornate town houses, attractively located beside their leafy communal gardens. Here we see a fine array of Flemish and crowstep gables, spacious balconies, and terracotta frontages on houses built around 1880.

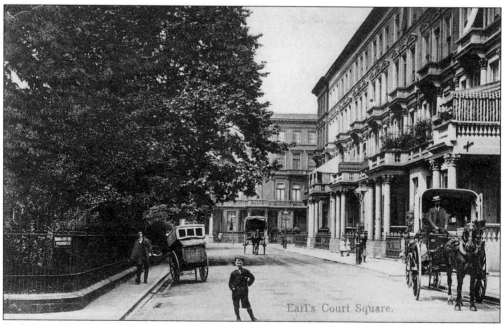

Earls Court Square, *c.* 1906. A typical Kensington garden square, dating from 1872. There is the usual selection of horse drawn vans and a baker with hand cart and wicker basket. At a time when street cries and musicians proliferated in London, a notice on the garden railings warns that they are prohibited here.

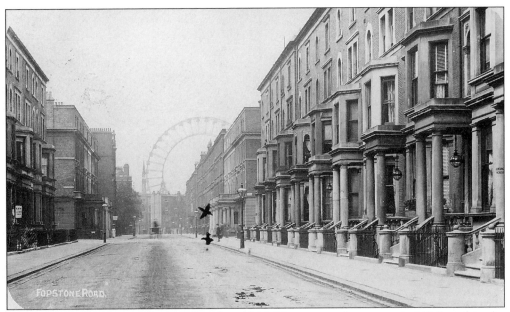

Mid-Victorian houses in Fopstone Road, *c.* 1906. This postcard was sent in 1910, and in the message, the sender writes that the view had been taken before the road acquired a new name, Nevern Place. The 'X' on the card denotes 'our house'; many Edwardian cards were defaced by their senders in this way. The Great Wheel towers above the houses, and dwarfs the spire and bell-cote of St Cuthbert's, Philbeach Gardens.

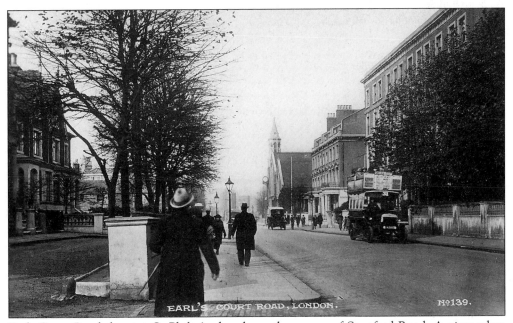

Earls Court Road showing St Philip's church on the corner of Stratford Road. A view taken from West Cromwell Road around 1920, before road widening had reduced the seclusion of the houses on the left.

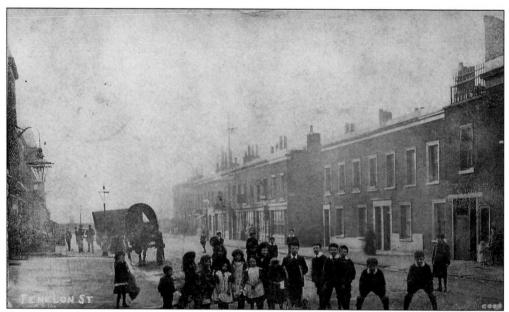

Fenelon Road from Warwick Road, *c.* 1906. A rare photograph of this humble but populous street that made way at the end of the 1930s for the six-lane Cromwell Road extension and viaduct. In the centre of the photograph, a few of the tiny shops that serviced this neighbourhood included those of George Wells, chandlers; Walter Goodman, bootmaker; and Miss Sophia Biggs, confectioner. There was also a laundry, wardrobe dealer, and a marine store dealer. The opening into long forgotten Shaftesbury Road is also seen. The Kensington canal once ran where the railway lines are at the western end of Fenelon Road, and remarkably, an old lock keeper's cottage has survived to this day, just out of sight of this view. This is another photograph by Edwin Cook who, on this occasion, has attracted lively interest from local youth.

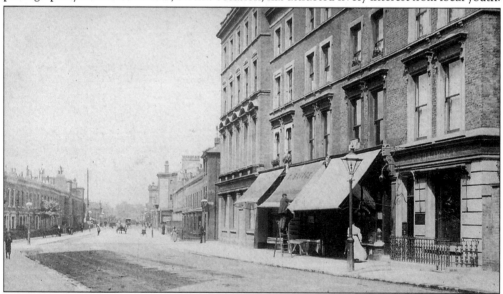

Warwick Road, *c.* 1906. This peaceful scene gives little indication that it would one day become one of the busiest traffic junctions in Kensington. To accommodate the new West Cromwell Road, eight lanes wide here, all the houses and shops on the right were pulled down.

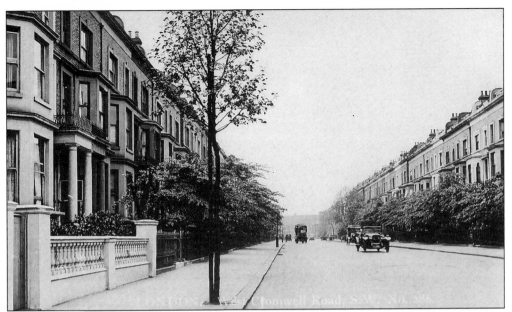

West Cromwell Road from Earls Court Road, c. 1920. This was an unremarkable road until its modern development as a six-and eight-lane superhighway that destroyed all the houses on the south (left) side.

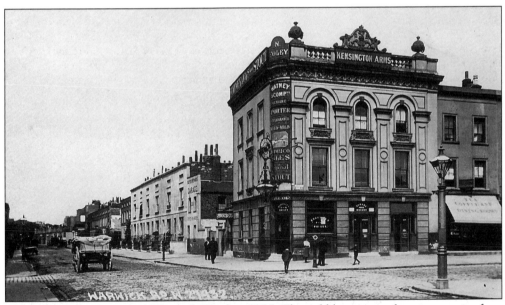

The Kensington Arms and Warwick Road, c. 1905. The cobble stone surface was a rarity for a main road in Kensington, but it was needed here to withstand the heavy horse-drawn wagons that serviced the coal depot and railway sidings that once existed to the left of this view. These were built on the site of the disused barge terminal of the old Kensington Canal. Work was dirty and dusty in the coal depot, but the splendid Kensington Arms was close by to quench formidable Victorian thirsts. Sainsbury's incredible Egyptian style Homebase store now stands on the sites of the old sidings, and although the pub has closed, the building still stands on the Pembroke Road corner.

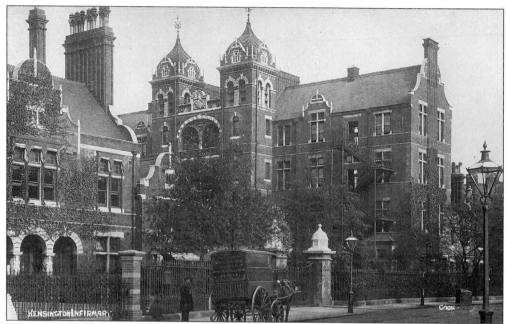

St Mary Abbots hospital, Marloes Road, was a building of 1871 vintage that developed beside the former Kensington workhouse, whose small infirmary began the tradition of medical care here in 1848. The hospital was replaced around 1990 by Kensington Green, a modern housing complex, but the old workhouse still survives in the midst of it.

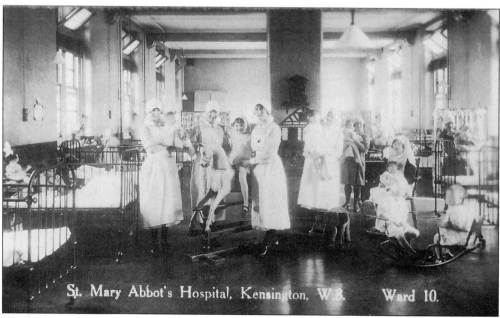

Ward 10, the Children's Ward, St Mary Abbots hospital, *c.* 1928. A picture that evokes the 'twenties', even the nurses caps mirror the essential feminine fashion accessory of that decade, the cloche hat.

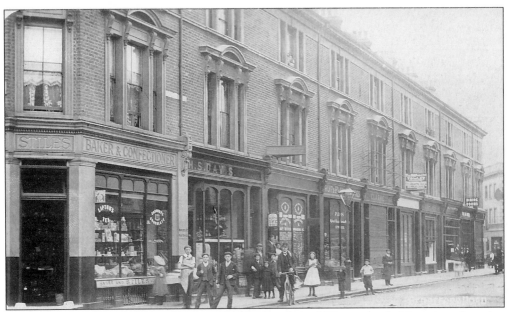

Stratford Road from Marloes Road, *c.* 1906. Another of Kensington's Victorian shopping parades with the premises of Charles Stiles, baker; Henry Davis, chemist and post office, and Agnes Copper, newsagent. John Plows fruit and flower shop stood next to the shuttered emporium of John Clarke, cheesemaker.

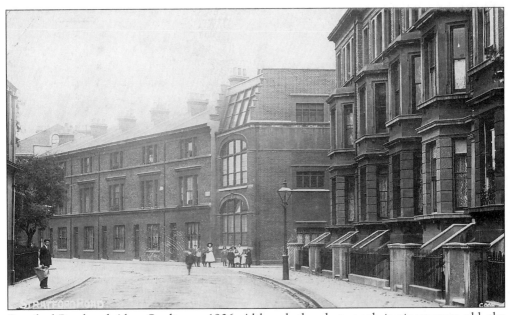

Stratford Road and Alma Studios, *c.* 1906. Although the photograph is ninety years old, the street scene has changed little in that time, unlike the traffic conditions. The houses are mid-Victorian, but the distinctive Alma Studios (centre) were not built until 1902.

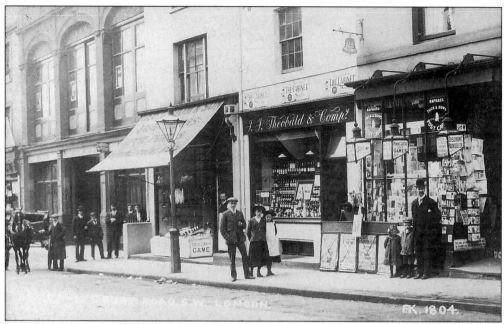

Earls Court Road, *c.* 1904. The shops at the northern end of Earls Court Road included an early motor dealer, the Century Motor Company; George Groom and Son, fishmongers; Jas Theobald & Co., wine merchants and, on the right; John Picknell's, his newsagents shops wonderfully jam-packed with paper ephemera of all kinds, including numerous postcard pictures of Edwardian actresses. They were very popular with the collectors of the day, and were sold in such vast quantities that, even today, they exist in great numbers.

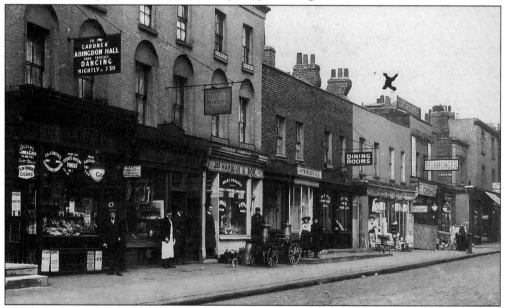

Earls Court Road, *c.* 1904. The shops between Pembroke Mews and Pembroke Place included those of Mrs Hannah Conybeare, tobacconist, and M. Holden, milliner 'from the West End'. A sign points towards 'Gardner's Abingdon Hall' in Park Terrace (now part of Cope Place), where there was dancing nightly.

Four
Kensington Gardens

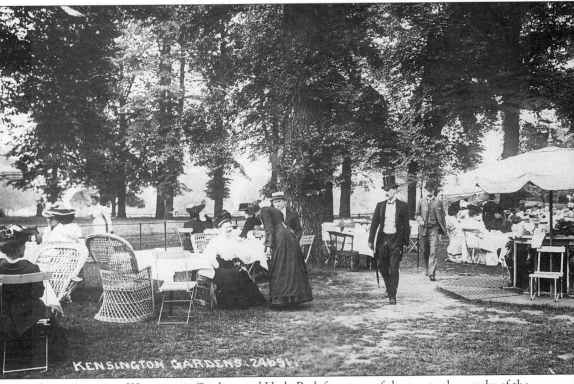

KENSINGTON GARDENS 24691

The green acres of Kensington Gardens and Hyde Park form one of the great urban parks of the world, where the hustle of town can be left behind, although the continual rumble of distant traffic is a constant reminder of the encircling city. Kensington Palace at the western end of Kensington Gardens was once a private residence, built in 1605 and called Nottingham House, but it became a Royal residence when sold to King William III at the end of the seventeenth century. Queen Victoria was born at Kensington Palace in 1819, and it was there that she learned of her accession to the throne following the death of King William IV on 21 June 1837. Kensington Gardens were originally the private gardens of the palace to which public access was eventually allowed. A high standard of dress was required at first, and some two centuries later, that tradition appears to have been maintained, as the formally attired Edwardians in the photograph take tea in the park's refreshment gardens. Note the elegant wicker seating interspersed with the park's more unforgiving wooden chairs.

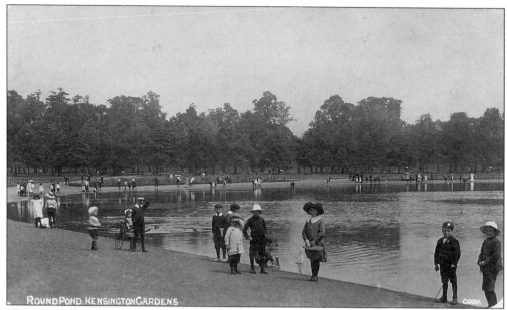

The Round Pond, *c.* 1906. The Basin or Round Pond as it is popularly known, is actually oval in shape, with flattened sides. It was constructed from 1726-28 as a garden feature, and when the gardens became open to all, it soon became a children's favourite, being an ideal size for model boating. Fishing for tiddlers, feeding the wildfowl, and skating in winter have all been enjoyed here by generations of local children. Note the variety of headgear worn by the youngsters as they take a break from their aquatic pleasures to pose for the camera.

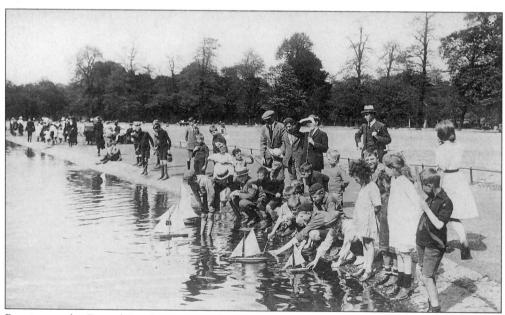

Boating at the Round Pond, *c.* 1920. The benign waters of the Round Pond have seen the launch of a veritable armada of model craft through the decades.

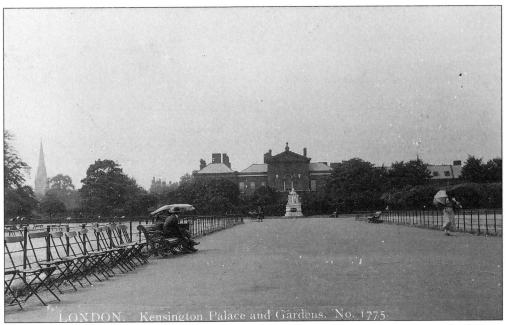

Kensington Palace from Kensington Gardens, *c.* 1920. This is the wide footpath that leads from the Round Pond to the Broad Walk and Kensington Palace, with the statue of a youthful Queen Victoria created in 1893 by her talented daughter, Princess Louise. The spire of St Mary Abbots church is seen to the left, with some of the park's notoriously uncomfortable seating in the foreground.

Kensington Palace from Palace Green, *c.* 1920. The oldest surviving part of the palace is Clock Court, centre of picture, dating from the time of Sir Christopher Wren, who carried out extensive alterations to the original house.

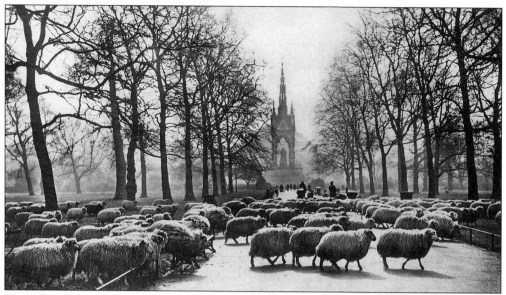

The Albert Memorial, Kensington Gardens, *c.* 1920. The memorial to Albert, Prince Consort to Queen Victoria was designed by George Gilbert Scott, and completed in 1872, although the statue of Prince Albert beneath its richly decorated canopy was not unveiled until March 1876. The effigy of Prince Albert is portrayed holding a copy of the catalogue for the Great Exhibition, the site of which is a few yards to the east of the Albert Memorial. Flocks of grazing sheep were often seen on many of London's parks and commons early in the century. Apparently, sheep shearing was carried out in Hyde Park.

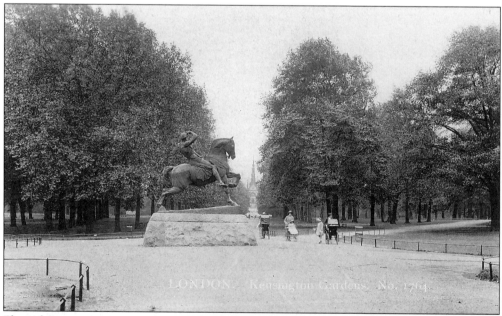

Physical Energy, an impressive statue by G.F. Watts, and dating from 1907, stands at a point where six foot paths cross, making a fine focal point from all of them. A photograph from around 1918 showing some of Kensington Gardens' famous pram pushing nannies, and the Albert Memorial in the distance.

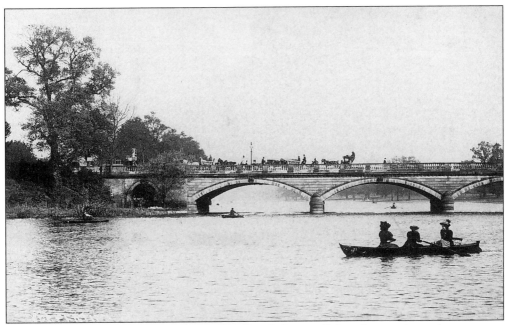

The Serpentine Bridge, *c.* 1904. Three Edwardian ladies in all their finery take to the waters on the park's magnificent lake. The Kensington end of the Serpentine is called the Long Water, and the whole lake was created when the shallow valley of a sluggish stream, the Westbourne, was excavated and dammed at its eastern end in Hyde Park. The surplus water still flows out of the Serpentine at this point, where a pretty waterfall carries it into a tiny lower pool and underground to the Thames. The bridge is by Rennie, and dates from 1826.

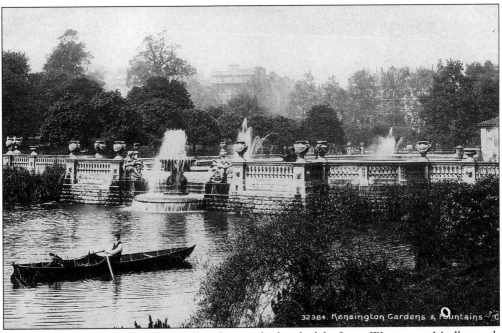

The Italian Water Garden. This idyllic place at the head of the Long Water near Marlborough Gate, was laid out in 1861, and has changed little in over a century.

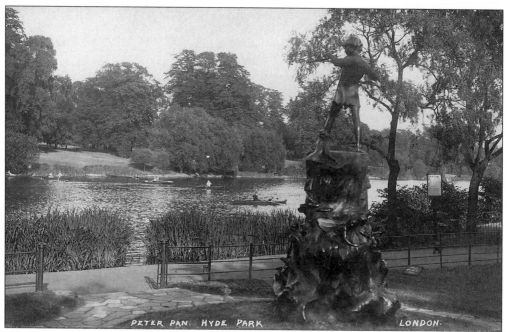

Peter Pan, Kensington Gardens, *c.* 1914. Sir George Frampton's statue of J.M. Barrie's eternal character has attracted generations of children, their hands having given a fine polish to the fairies and small animals that crowd the base of the statue in its enviable position overlooking the Long Water.

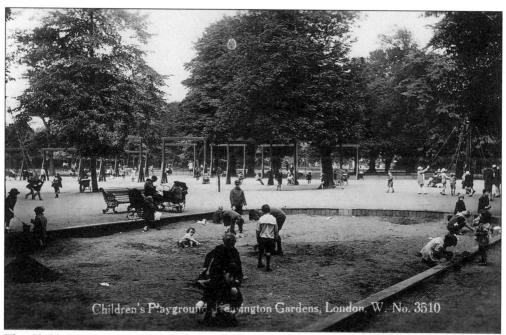

The Children's Playground, Kensington Gardens, *c.* 1925. A fine place for the more energetic to let off steam, at the north western corner of Kensington Gardens.

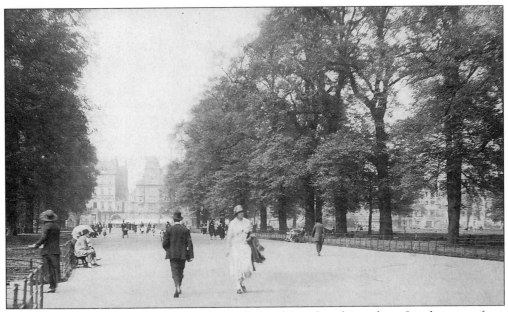

The Broad Walk, c. 1920. What must surely be the widest footpath in London runs from Bayswater Road to Palace Gate, and is seen here with its fine avenue of elms in full splendour before their controversial destruction. Once the promenade of nannies and their charges, the Broad Walk now plays host to the contemporary pursuits of roller blading and skate boarding.

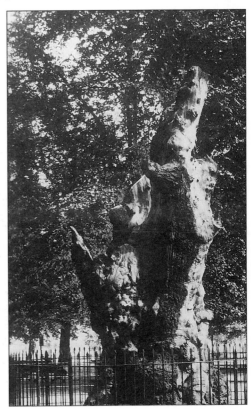

The Elfin Oak, c. 1925. This venerable tree trunk, reputedly 800 years, was brought here from Richmond Park. It's gnarled surface was carved by Ivor Innes into a fantasy of gnomes, elves, fairies and animals to the delight of it's young visitors.

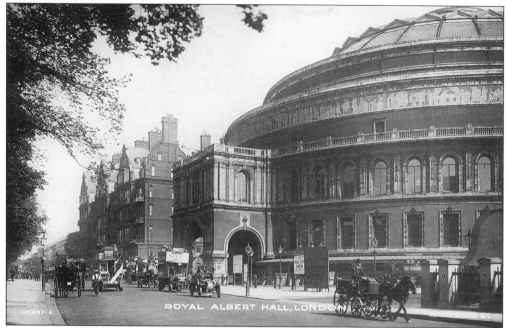

The Albert Hall, Kensington Gore, *c.* 1907. The foundation stone of the world famous concert hall was laid on the site of the former Gore House by Queen Victoria on 20 November 1868, and she also opened the building on 29 March 1871. This is the northern part of the immense circular structure, facing Kensington Gardens and the Albert Memorial.

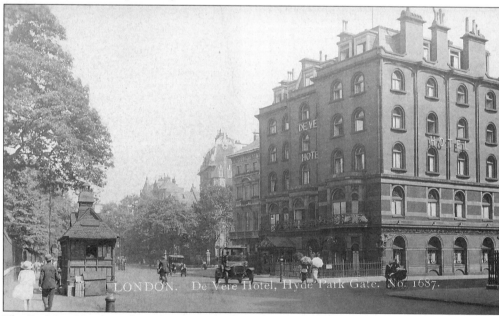

The De Vere Hotel, Hyde Park Gate, *c.* 1920. This Victorian hotel still stands at the De Vere Gardens corner, and enjoys a fine view of Kensington Gardens. The name was derived from that of Aubrey de Vere, the first Lord of the Manor of Kensington. The wooden cabman's shelter with its tiny gables, shingled roof, and ornamental chimney, has been moved to a more convenient position in Kensington Gore where the road is wider.

Five
Kensington High Street

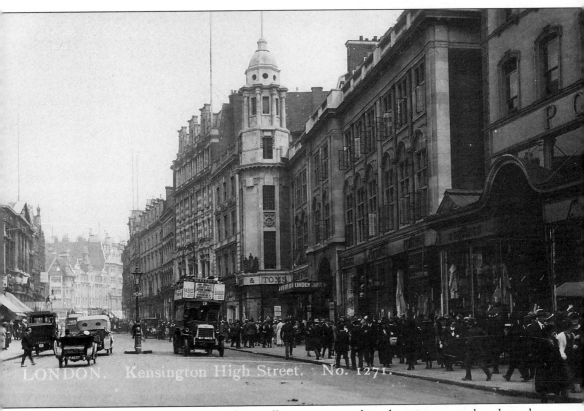

LONDON. Kensington High Street. No. 1271.

Kensington High Street's transition from village street to urban shopping centre largely took place after the middle of the nineteenth century, when the arrival of the Metropolitan Railway at a new station on 1 October 1868, was followed in 1870 by that of Mr John Barker, late of Whiteley's store in Westbourne Grove. His modest first shop prospered and expanded through the decades to become a vast emporium, which together with adjoining Derry & Toms and the smaller Pontings, provided Kensington High Street with a trio of department stores to rival those of Oxford Street, The view from around 1920 shows typically thronged pavements, with Pontings store on the right; High Street Kensington station, and beyond, Derry & Toms who at the time inhabited a motley collection of old buildings. Further on were Barker's old premises in a High Street considerably narrower than it is today.

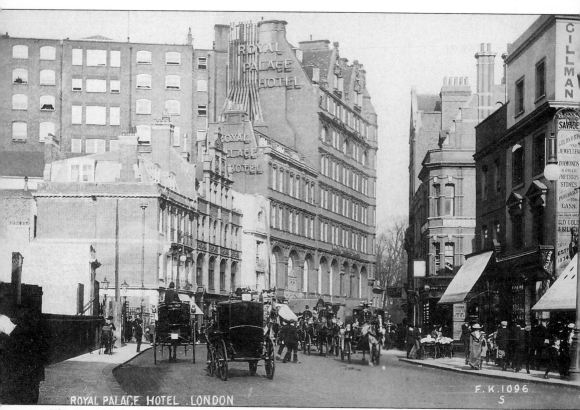

ROYAL PALACE HOTEL . LONDON

F.K.1096
5

The Royal Palace Hotel towered over the eastern entrance to Kensington High Street until its replacement in 1965 by the Royal Garden Hotel's grim slab block. When this photograph was taken, around 1903, the adjacent Empress Assembly Rooms stood out brightly in a fresh coat of paint. Slater's store and restaurant is seen with the gabled frontage, alongside the Duke of Cumberland pub. In the tiny Cumberland Yard beside the pub were the premises of wheelwright George Hodgson. As Cumberland Yard was not an official street name, his address was, delightfully, 18½ Kensington High Street. To the left were the gates leading to Kensington Palace Gardens, a private road lined with Victorian mansions of such splendour that the nickname of 'Millionaires Row' is particularly appropriate. The empty site to the left was to be occupied by part of a new Barker's store in 1925, and to the right, the opening led to Kensington Court, where a pioneering electrical sub station was built in 1888, the frontage of which can still be seen.

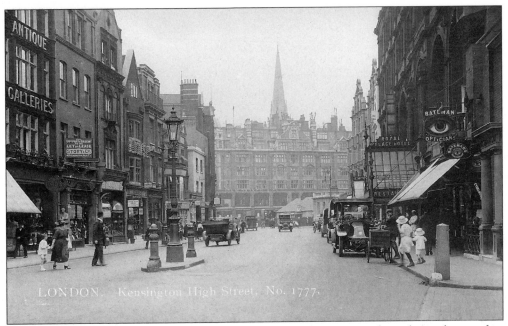

Kensington High Street, c. 1919. The Royal Palace Hotel is seen on the right, with one of its ground floor shops occupied by Bateman's, the opticians, whose 'eye' shop signs were familiar in most high streets. Beyond the empty site, temporarily home to a small YMCA hut, was Barker's north block on the Old Court Place corner, with the spire of St Mary Abbots rising above. The left (south) side of the road had a variety of smaller shops including the Manhattan Tea and Luncheon Rooms, the Bath Bun shop and a branch of Express Dairies.

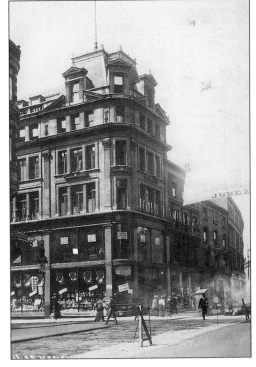

John Barker's shop, Kensington High Street by Young Street, c. 1903. Although the western end of Barker's was rebuilt early in the 1930s, this eastern side was not completed until 1958. The smoky roadworks indicated the presence of the molten tar once used to cover the old wood block road surfaces.

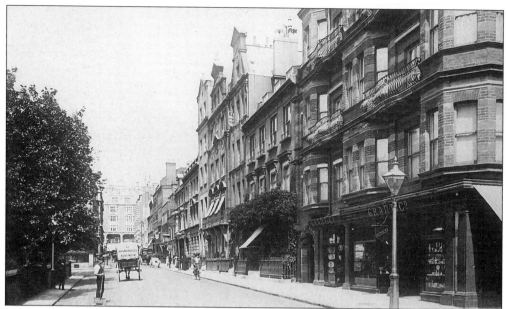

Originated around 1685, Kensington Square and Young Street (once called Kings Square) it was to become the first of many garden squares so characteristic of Kensington. Many of the houses have been substantially altered or rebuilt, particularly on the east side seen here, where a Barker's delivery van is shown heading for Young Street. This road was constructed to allow access to Kensington High Street from Kensington Square, and takes its name from the builder, Thomas Young.

Thackeray's House, Young Street, *c.* 1908. This is the house in which the novelist William Makepeace Thackeray lived from 1846, and where *Vanity Fair* and other works were written. The attractive bow frontage would have given Thackeray a glimpse of the trees in Kensington Square from his windows.

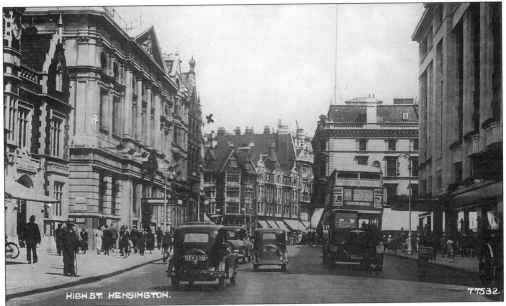

Kensington High Street looking east, *c.* 1935. The rebuilding in 1931 of Derry & Toms (right) created a much wider High Street, the extent of which is well caught here, with Barker's old store still standing in the distance on the old building line. The former Kensington central library is seen on the left in premises built in 1851 as Kensington Vestry Hall. The library moved to a fine new building in 1960; the old premises acquiring a new lease of life as a bank.

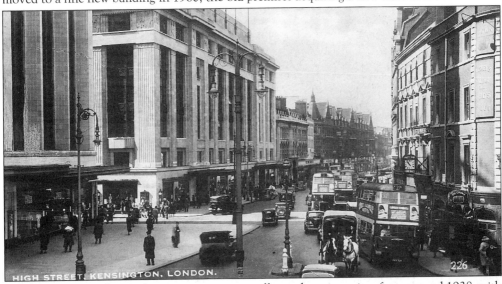

Kensington's trio of great department stores are all seen here in a view from around 1938, with Derry & Toms new emporium dating from 1929-31 standing centre stage. High above the street are the celebrated Derry's Roof Gardens, where mature trees, a stream, waterfall and themed areas including Spanish and Old English gardens flourish. Marks & Spencer and British Home Stores now have branches in the Derry & Toms building, and Barker's (left) now shares its retail area with other shops. Associated Newspapers, the publishers of London's daily newspaper, the *Evening Standard*, has it's headquaters in another part of Barker's building, now called Northcliffe House.

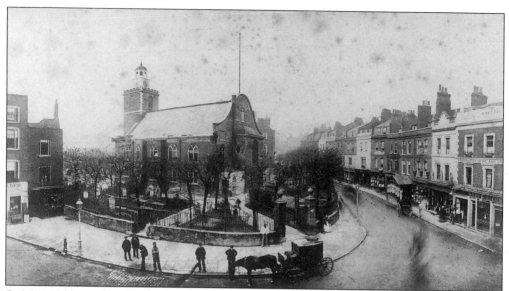

St Mary Abbots church, *c.* 1866. This was Kensington's former village church, dating from 1696. The church was already in a dangerous structural condition when this photograph was taken and was demolished to be replaced in 1869 by the magnificent church we know today. The lofty elegant spire was modelled on that of Bristol's St Mary Redcliffe, but was not completed until 1879. To the right was Church Street, with the old Civet Cat pub on the High Street corner. The Prince of Wales pub is also visible here; its premises were rebuilt in 1874.

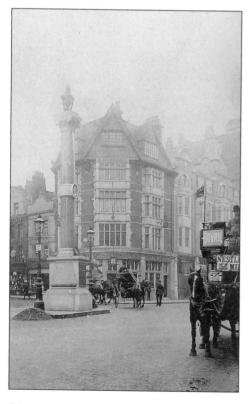

Kensington High Street, *c.* 1904. The Civet Cat pub is seen occupying its flamboyant new Jacobean style premises on the Church Street corner, with new shops, as yet unlet, next door. Church Street was not known as Kensington Church Street until 1938. The memorial to Queen Victoria, designed by H.L. Florence and unveiled on 19 October 1904, then stood in the middle of the road, but with the widening of the High Street in 1934, the memorial was moved to a more peaceful location in Warwick Gardens. The Hammersmith bound horse bus on the right proudly flies the Union Jack from its top deck, for this was one of the vehicles owned by the London Road Car Company, who had adopted the Union Jack as a trade mark. The company's motor buses also used the fleet name 'Union Jack', (see page 35).

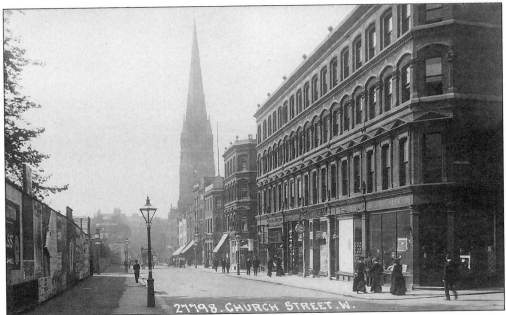

St Mary Abbots church from Church Street, *c.* 1906. The empty site on the left awaits the arrival in 1926 of York House, the imposing premises of the Gas Light and Coke Company. Dukes Lane is seen on the right, with Victorian shops stretching away towards St Mary Abbots, where some earlier buildings survive from Kensington's village past. A tiny weatherboarded house in Holland Place is a particularly rare survival.

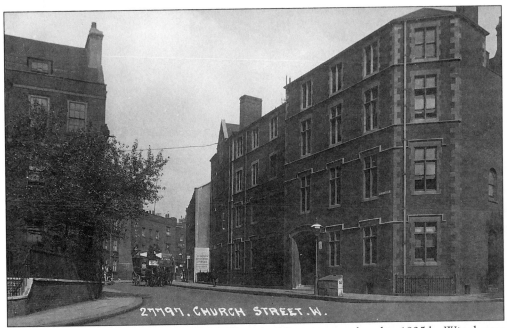

Church Street by Vicarage Gate, *c.* 1906. These buildings were replaced in 1935 by Winchester Court, a large complex of flats built in the sleek streamlined style of that decade. To the left was the Church of Our Lady of Mount Carmel, destroyed during the Second World War and rebuilt in the late 1950s.

79

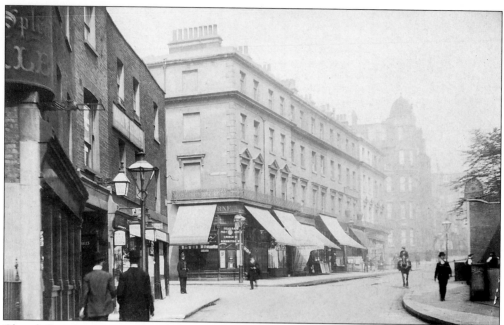

Church Street curves gently uphill on the way to Notting Hill, past the fine row of shops once known as Allason Terrace after its architect, Thomas Allason. This survives today with fascinating antique shops replacing the more domestic establishments of yesteryear that included a bootmaker, dairy and post office. On the left, the shops have all gone, as has the Old George pub and Old George Yard, where stabling was available. There are modern flats here now, but their name, George House, recalls the establishment that preceded them.

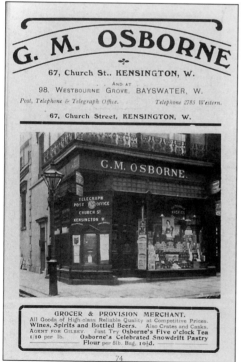

George Osborne's grocery store and post office at the corner of Church Street, and Campden Grove, c. 1910. The shop eventually became a branch of well known chain stores W.H. Cullen.

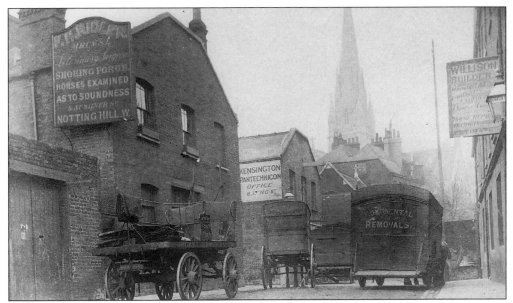

St Mary Abbots from Hornton Place, *c.* 1890. Hornton Place was a commercial byway off Hornton Street, with businesses that included the shoeing forge of F.H. Ridler, who also had premises at Silver Street, Notting Hill. Kensington Pantechnicon, the furniture removers, can be seen on the corner of Drayson Mews, and on the right were Willison's, the builders. The gathering of wagons included those of Rickett & Smith, coal merchants; Kensington Pantechnicon; and the Compressed Air Carpet and Tapestry Cleaning Co..

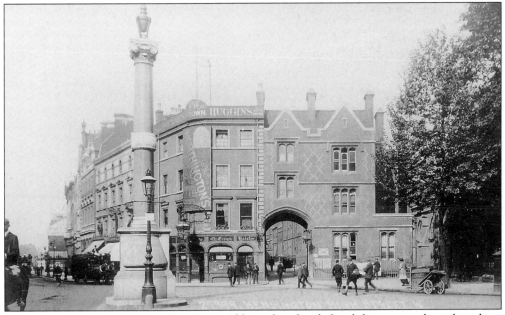

Kensington High Street, *c.* 1905. St Mary Abbots church is behind the trees to the right, where a cloister leads to one of the church entrances. The police station, dating from 1873, is seen by the arched entrance to Church Court, with the Crown Hotel next door. The buildings, have survived the High Street's road widening schemes, but the Queen Victoria Memorial has been moved away.

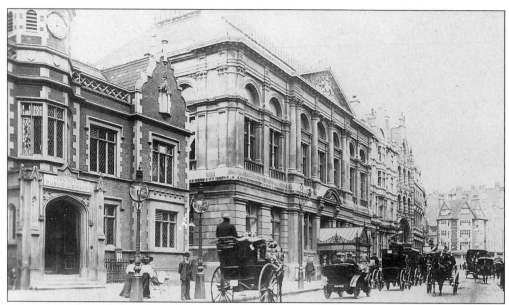

Kensington central library and Kensington Town Hall, *c.* 1905. The old town hall dated from 1880, and was controversially demolished following the building of a new civic centre in Phillimore Walk during the early 1970s.

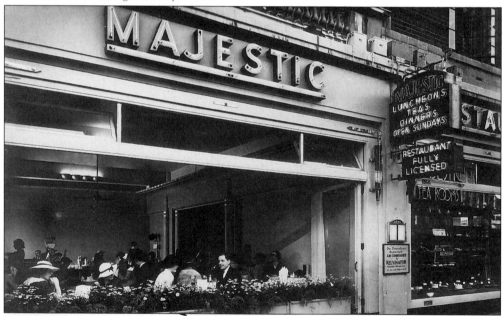

The Majestic Restaurant, 142-144 Kensington High Street, *c.* 1939. Kensington has possibly as varied a selection of restaurants as can be found in London, but at the end of the 1930s this one was something of a trend setter; an 'open air' restaurant, unique in London, apparently. The front windows folded back onto the sunny south facing side of the High Street and it must have been very pleasant in spite of the aromas from the busy motor traffic. It was then the last word in modernity, with new neon signs and art deco lettering. The prices seem mouth-watering today: three course luncheons were 1/9d, about 9p, and four course dinners were 2/3d and 3/6d, about $11\frac{1}{2}$p and $17\frac{1}{2}$p.

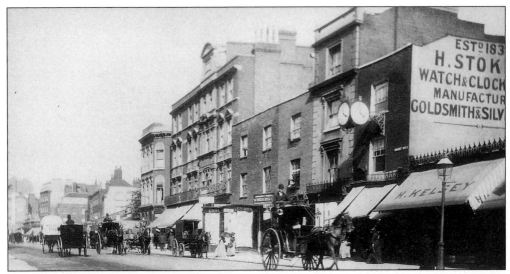

Somerset Terrace, Kensington High Street, *c*. 1890. This name vanished long ago, as did the buildings which included the shop of H. Stokes, the clockmaker, established in 1830. A small opening led to Somerset Yard, where jobmaster W. Buckeridge plied his trade. Rebuilding took place in 1909, with H. Stokes maintaining their presence by moving into the new shop on the site of the old one. One of Kensington's lost cinemas, the Royal, was here during the 1920s. A more recent closure was the Adam & Eve pub, seen here on the corner of the mews to which it gave its name.

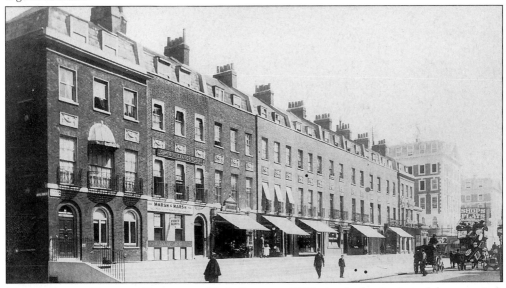

The Phillimore Terraces, Kensington High Street, *c*. 1905. At the beginning of the twentieth century, the north side of Kensington High Street from Holland Walk to Hornton Street, was occupied by the four Phillimore terraces, built by William Phillimore around 1787. These were town houses with gardens at the front, but as the High Street rose in prominence as a shopping centre the terraces became increasingly commercial, some having shop fronts added. The terraces were progressively redeveloped as large blocks of flats and shops, and the first of these, Hornton Court, can be seen here in the distance as building nears completion. The terrace in the photograph lasted until 1931, when it was replaced with Phillimore Court.

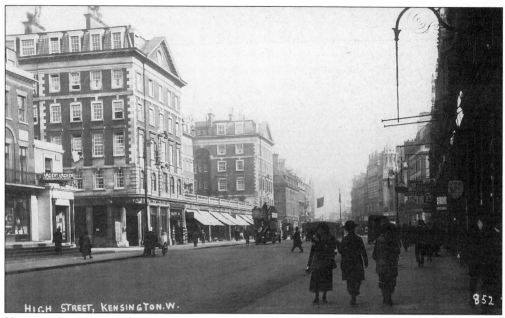

HIGH STREET, KENSINGTON.W.

852

Hornton Court from Adam & Eve Mews, *c.* 1925. Hornton Court was built in 1905 on the site of the most easterly of the Phillimore terraces, Lower Phillimore Place. To the left, on the Campden Hill Road corner, were the premises of well known local photographer, Argent Archer. The stepped pavements were similar to those of Brompton Road.

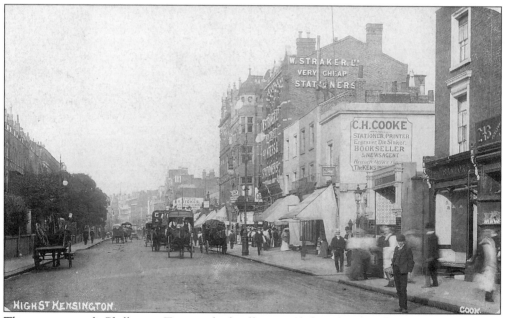

HIGH ST KENSINGTON.

The more westerly Phillimore Terraces had still retained their front gardens in this view from around 1905, taken from Earls Court Road. On the right was the gated entrance to the Church of Our Lady of Victories, rebuilt from 1955-58 following wartime destruction. The small shops all vanished a long time ago.

Upper Phillimore Place from Earls Court Road, *c.* 1906. The building of Troy Court, in 1931, transformed this road into the broad shop-filled High Street that we know today. On the left is the entrance to Holland Walk, whose gates were set back when the road was widened.

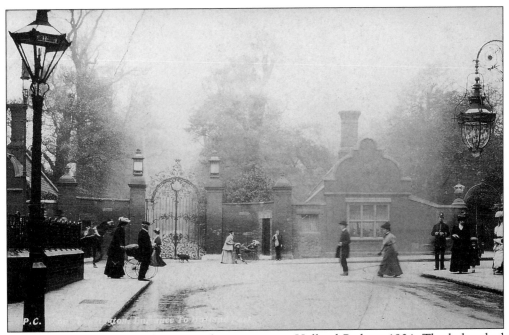

The lodges and ornamental gates at the entrance to Holland Park, *c.* 1904. The lodges had shaped gables that reflected those of Holland House (see page 97), but were destroyed by bombing during August 1944. The opulent hanging lamp with its etched glass (right), belonged to the former Star & Garter pub on the Earls Court Road corner.

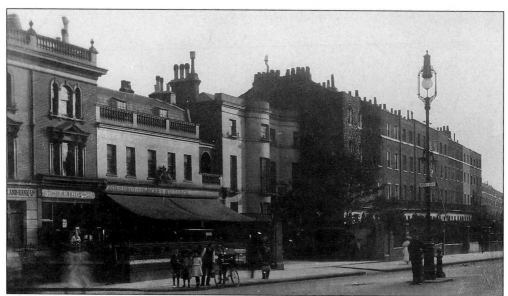

Leonard Place, Kensington Road, *c.* 1905. Now part of Kensington High Street, Leonard Place formerly ran from Earls Court Road to Earls Terrace. It acquired an ultra modern aspect in 1926 when the magnificent Kensington Cinema (now the Odeon) was built here. A block of flats, Leonard Court, arose on the site of the distant terrace, while the premises with the sunblinds were home to Henry Whitlock's Automobile Company. This old firm, established in 1778, only had horse carriages on display when this photograph was taken, these being the basis of the original business.

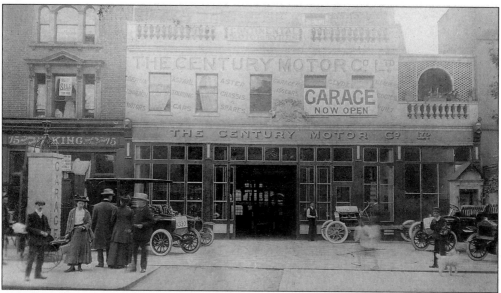

Leonard Place, *c.* 1907. By this time the motoring craze was well under way, and Henry Whitlock's premises had become the Century Motor Co. Ltd., with a forecourt containing a selection of cars for sale including the limousine on the left for £330, and an open top model on the right for £290. There was also a garage accommodation for 150 cars stretching back to Earls Court Road. Apparently, the sender of this postcard is pictured somewhere on it '... can you see me here, isn't it rotten'.

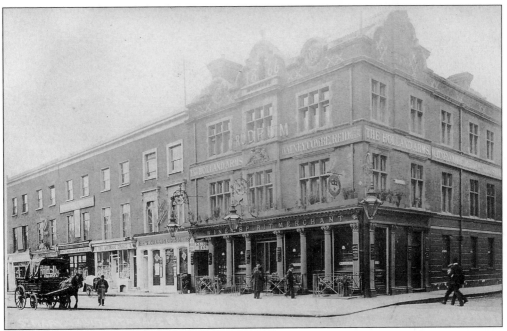

St Mary Abbots Terrace, Kensington Road, *c.* 1905. The Holland Arms at the Holland Lane corner was built in 1866, but the terrace it adjoined was far older. The whole terrace was rebuilt in modern times as was the pub and Kensington Road, from Argyll Road and Earls Court Road to Addison Bridge, was added to Kensington High Street at the end of the 1930s.

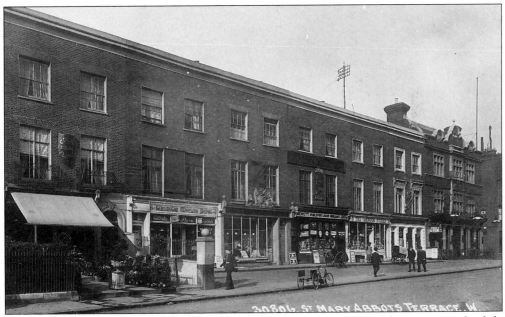

St Mary Abbots Terrace, *c.* 1905. This long terrace contained shops at the eastern end, while the western part was residential. One of the shops was Henry Burn's 'Kensington Wheeling Depot', a cycle and pram shop where, in those early days of motoring, 'Pratts Motor Spirit' for the car could be obtained.

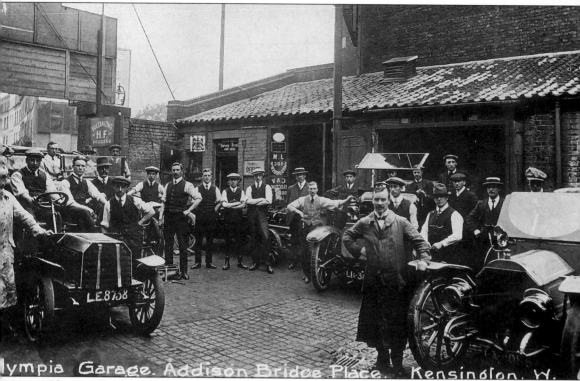

Olympia Garage, Addison Bridge Place, *c.* 1912. The Olympia Motor Mart Company's well populated business was based in these former stables, near the West London Railway. One of Kensington's lost streets, Kensington Crescent, can be seen in the background. This site was used in 1948 for a large block of government offices, Charles House.

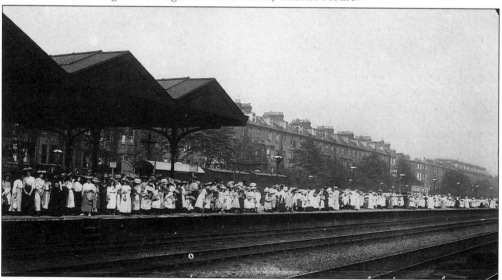

Kensington, Addison Road station, *c.* 1908. This station on the West London Railway opened in 1844, and is now known as Olympia. Here we see a platform full of excited young Fulham ladies as they await their train to take them on their outing to the pleasure resort of Bricket Wood in Hertfordshire.

Six

Notting Hill
and Holland Park

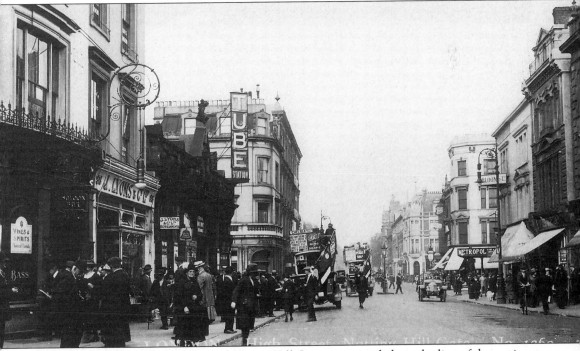

Kensington's 'other' High Street, at Notting Hill Gate, is situated along the line of the ancient highway that ran from London, through Tyburn (Marble Arch) to Uxbridge and thence westward. In the middle of the nineteenth century, the area was known as Kensington Gravel Pits, but 1 October 1868 saw the opening of the Metropolitan Railway's new station, and the usual selection of shops and housing soon followed. A station also opened on 30 July 1900 for London's first deep level tube service, the Central London Railway, which then ran from Bank to Shepherds Bush. The photograph, from around 1920, was taken from Pembridge Road, and shows both stations on opposite sides of the road, before the comprehensive rebuilding and road widening of the 1960s removed all the buildings to the right, and the surface booking halls of both stations in favour of a subterranean concourse.

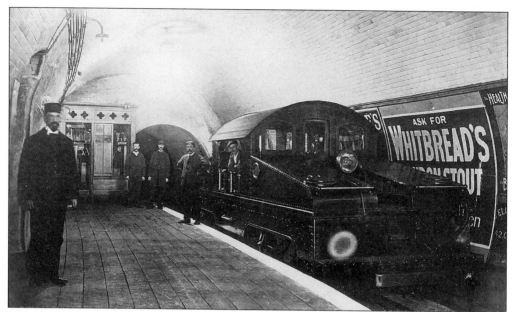

The Central London Railway, *c.* 1901. This was one of the thirty original 'camel back' electric locomotives that hauled the six-car trains on the Central Line. These were painted in a most attractive shade of crimson lake with gold lettering. The clean efficiency of the new service proved popular due in part to the lack of the noisome vapours that wafted around London's steam operated underground railways. A ticket cost 2d to any destination, hence the line's nickname 'Two Penny Tube'. The wood plank platform would be an unacceptable fire risk today.

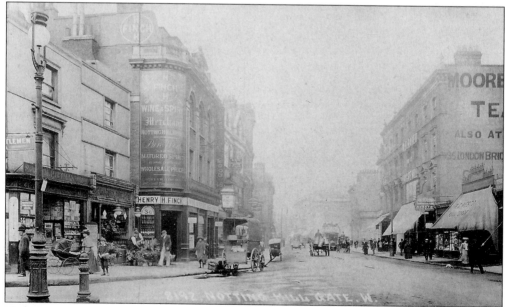

High Street, Notting Hill Gate from Church Street, *c.* 1905. The rebuilding of the High Street with 1960s concrete horror blocks swept away much of what is seen here including the site of Matthew Pittman's newsagent shop on the Church Street corner (left) and the Hoop public house.

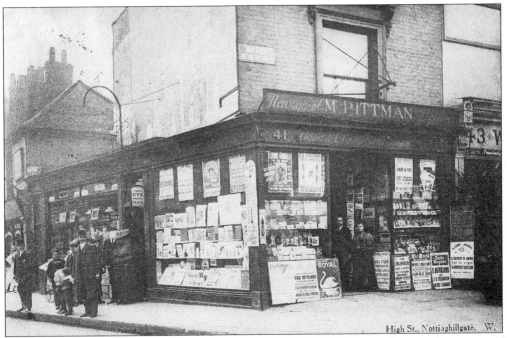

Mr and Mrs Matthew Pittman stand at the door of their newsagents shop at the corner of Church Street and High Street, Notting Hill Gate, around 1906.

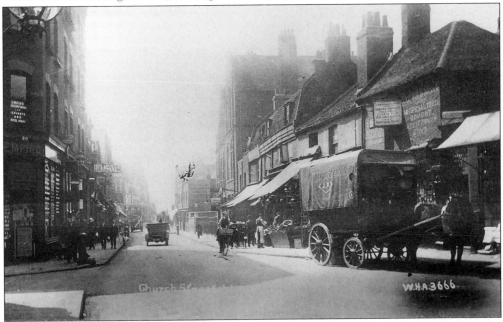

Church Street, *c.* 1910. A little of the flavour of Notting Hill's rural past seemed to linger at the narrow northern end section of Church Street with these venerable old buildings still standing. The road is considerably wider now, the old shops and the former board school having been replaced by clinical sixties concrete. There have been two street name changes here; the original name of Silver Street being replaced by Church Street, and during the 1930s it became Kensington Church Street. (Ron Elam Collection).

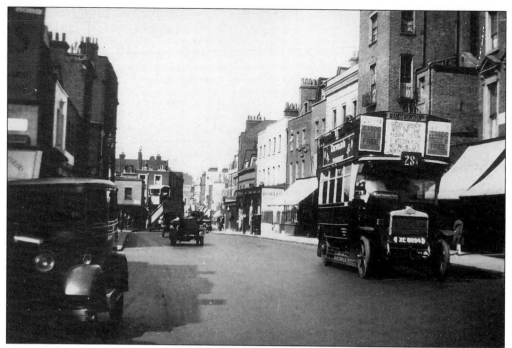

Church Street looking north from Campden Street, August 1930. This part of Church Street escaped much of the rebuilding of the northern end, and many of the eighteenth- and nineteenth-century buildings still stand. The Wandsworth bound 28a bus was old fashioned even in 1930 with its solid rubber tyres, most vehicles running on pneumatic tyres by this time.

Newcombe Street, *c.* 1928. In close proximity to some of Kensington's most affluent roads were small pockets of workers' houses like this. Uxbridge Street is seen in the distance, with the back of the Metropolitan station just visible. Although the street name is still extant, the houses have gone and the road is merely a car park.

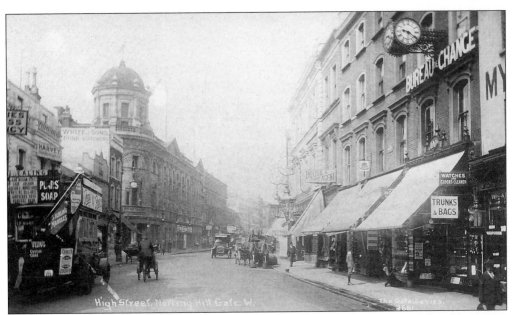

The Coronet Theatre, c. 1912. Designed by W.G.R. Sprague, the theatre opened for business in 1898 and, before it began showing films in 1916, stage appearances included those by Sarah Bernhardt, and Zena and Phyllis Dare. The cinema still stands in a fine state of preservation. The buildings on the opposite pavement disappeared with the road widening of 1962, which removed the Coach & Horses pub, where a brewer's dray is seen making a delivery, as its horses investigate the delights of their nosebags.

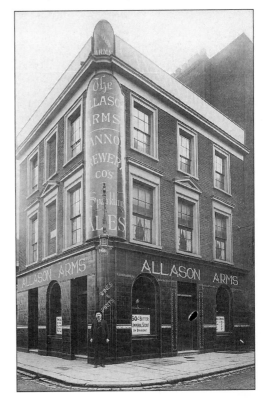

The Allason Arms, Uxbridge Street, c. 1910. This handsome structure is named after Thomas Allason, the architect responsible for many of Notting Hill's Victorian buildings. Some of the lettering on the tiled frontages show the influence of the Art Nouveau style that was fashionable around the turn of the century. Off license, or 'out door' prices included a modest 6d (2½p) for a quart (two pints) of bitter in your own jug. The left side of the view shows part of Ernest Street, renamed Farm Place in the 1930s. Eardley House, a modern block of offices stands here now.

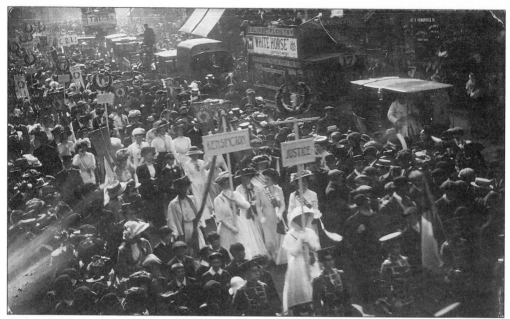

High Street, Notting Hill Gate, July 1910. A march by the ladies of the Women's Social and Political Union, the Suffragettes. Rallies were held in Hyde Park, at Speakers Corner, and Trafalgar Square.

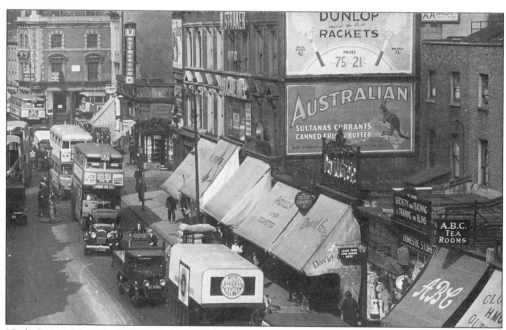

High Street, Notting Hill Gate, c. 1932. This shows how congested the narrow High Street was becoming, but it was to be another thirty years before the road was widened. The oldest buildings here were those on the right which had shops built out over their front gardens. These still stand together with the adjacent shops, but everything else has gone including the Midland Bank on the Pembridge Road Corner where W.H. Smith's now have a shop. The end wall still has billboards, but Dunlop tennis rackets are not currently on offer at 21/- (£1.05p).

Campden Street, *c.* 1906. The smart houses of Campden Street looked rather less fashionable in Edwardian days when they were fulfilling their roles as workers housing. The former Campden Arms on the corner of Peel Passage is now a private house.

Peel Street, *c.* 1906. This is another of the little streets that ran up the gentle slope to Campden Hill from Church Street. The houses have been attractively modernised, and their colourful frontages are in marked contrast to the Edwardian gloom of this photograph.

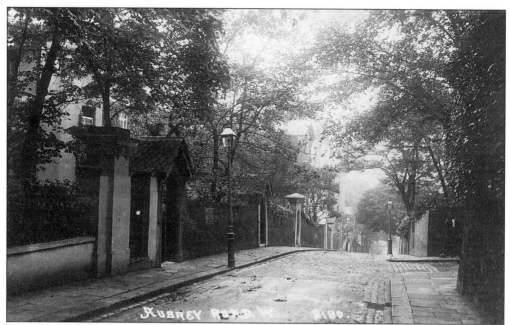

Aubrey Road, *c.* 1906. This is still a road of delightful and varied houses that drops steeply down the north side of Campden Hill to Holland Park Avenue. The sharp gradient is unusual in Kensington, giving the road something of the flavour of Hampstead. This is another of the roads that take their name from Aubrey de Vere, first Lord of the Manor of Kensington.

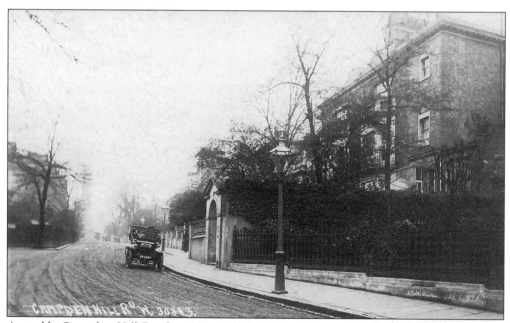

A muddy Campden Hill Road, *c.* 1906. Blocks of flats have replaced some of the Victorian houses adding to the diversity of the road's architecture, The outline of the Metropolitan Water Board's tower at the top of the hill can be seen in the distance. This was pulled down in 1970, and new flats built there.

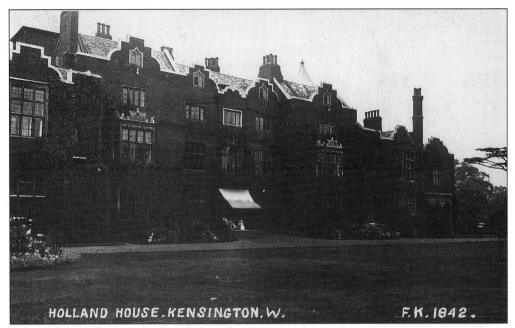

Holland House, Holland Park, *c.* 1904. This magnificent rambling mansion was originally the home of Sir Walter Cope, Chamberlain of the Exchequer in 1609, before it passed into the ownership of the First Earl of Holland in 1629, and subsequently to the Fox family, Lords Holland. The house was virtually destroyed early in the Second World War, and only the east wing survives beside the preserved ruins of the rest. The extensive range of outbuildings have been adapted to a variety of modern uses as part of the beautiful public park formed out of the grounds of the old house.

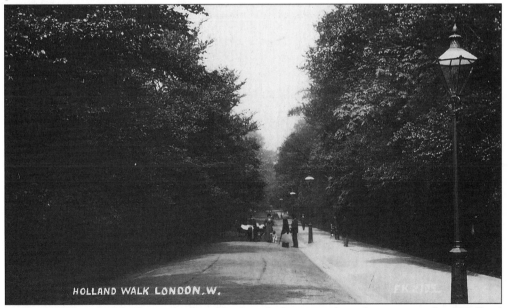

Holland Walk, *c.* 1905. This is the broad leafy path that runs along the eastern side of Holland Park to Holland Park Avenue. Part of Holland Park is unspoiled natural woodland, a fine amenity so close to the centre of the city.

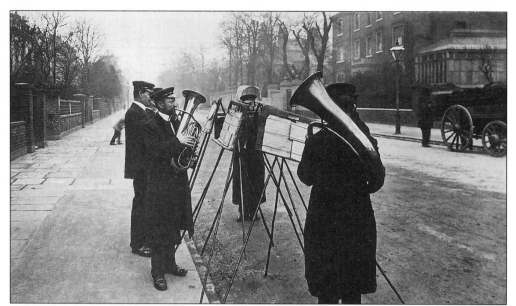

Life in Addison Road, the German Band, *c.* 1910. These itinerant musicians were considered to be among the elite of London's street entertainers as they descended on weathly areas of the city to perform their impromptu concerts. *The Blue Danube* was apparently an essential part of the repertoire, although the number of 'no musicians' street signs would suggest that not everyone appreciated their efforts.

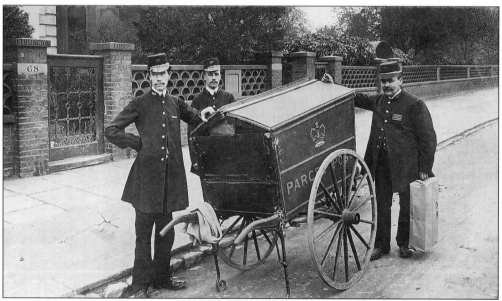

Life in Addison Road, the Parcel Post, *c.* 1910. This well manned and heavily laden handcart was pictured on its rounds, with the distinctive garden walls of Addison Road in the background.

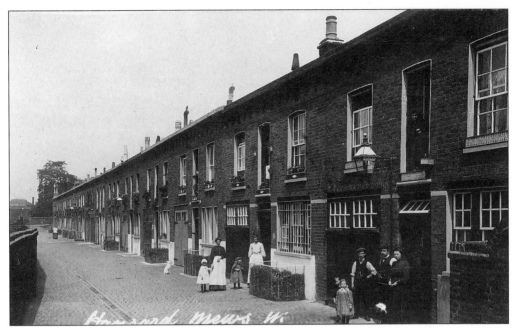

Hansard Mews, 1910. Life early in the century for coachmen and their families in the stables atmosphere of a London mews was not always agreeable. The days of the mews house as a fashionable residence had not yet arrived, but this view does show a most attractive and well-cared-for example, each house with window boxes, immaculate paintwork, and neat hay bins. In later years, the yellow London stock brickwork was painted in the rainbow hues of post-war gentrification.

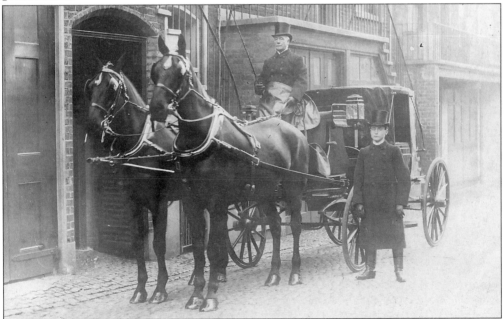

Holland Park Mews, c. 1908. A smart turnout of carriage and coachmen in the mews behind Holland Park's elegant houses. The mews was built between 1869 and 1879 and, when first sold, the freeholds cost between £87 and £147.

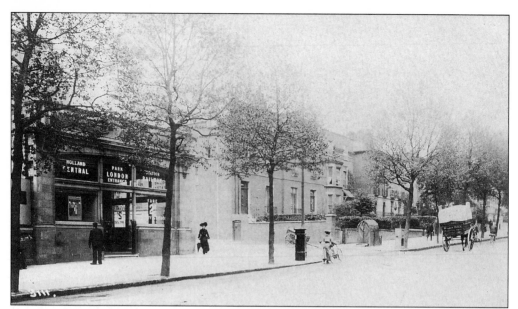

Holland Park Underground Station, c. 1904. The station was on the first section of the Central London Railway to be built, and was opened on 30 July 1900. It was to have been called 'Lansdowne Road', this being the street that runs to the side of it, but 'Holland Park' was thought to be more appropriate. The station's street level building was in the usual style of the Central Line, with a terracotta finish and white lettering. All the Central Line stations were designed to have upper floors built onto them, but Holland Park, like Notting Hill Gate, remained single storey.

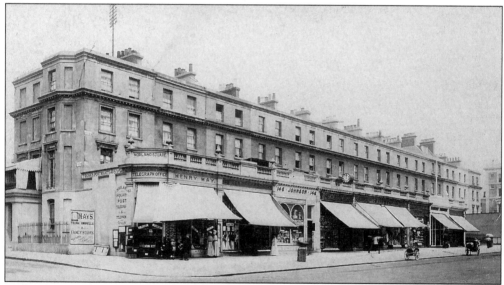

Holland Park Avenue, c. 1905. This is the continuation westwards of Notting Hill Gate on the road to Uxbridge, 'Uxbridge Road' being the street's original name. Some of the shops in this row were: Hunts Mills & Co., drapers; George Johnson, caterer; Henry Gandon, fancy draper; and at the Norland Square corner, Henry May's luggage shop, which included Norland Square post office. One of the latter's products appears to have been abandoned in the middle of the pavement.

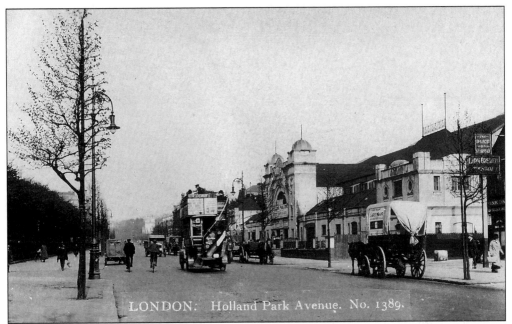

LONDON: Holland Park Avenue. No. 1389.

Holland Park Hall roller skating rink, *c.* 1920. This popular attraction in Holland Park Avenue opposite Royal Crescent was built in 1908 when the craze for indoor roller skating was at its height. As 'rinking' declined in popularity, the premises were used as motor showrooms, before their replacement in 1973 by the Kensington Hiton Hotel.

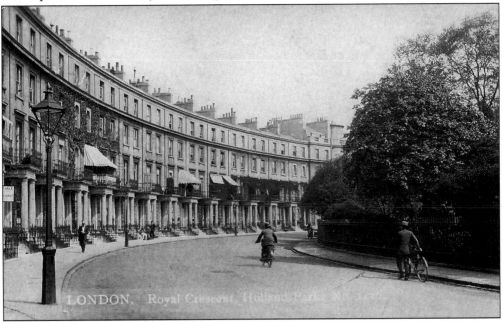

LONDON. Royal Crescent, Holland Park

Royal Crescent, *c.* 1920. Holland Park Avenue is one of the main approaches to Kensington from the west, and within a few yards of crossing the borough boundary from Hammersmith, the distinctive architecture of Kensington is soon apparent, with this elegant crescent to be seen on the north side of Holland Park Avenue. It was designed by Robert Cantwell and built around 1843.

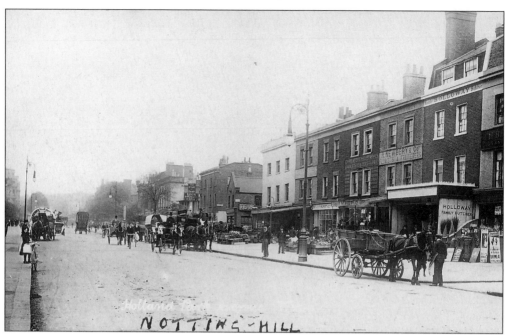

Holland Park Avenue, c. 1904. This photograph pre-dates the building of Holland Park Hall rink, whose site was then occupied by its original houses. These are seen beyond the Duke of Clarence pub, itself rebuilt in 1939. The blocks of shops on the right gave their sites for the huge traffic roundabout that marks the southern end of the West Cross Route motorway, the M41.

Holland Road from Holland Park Avenue, c. 1920. The building of the M41's southern roundabout cut a swathe of destruction through this part of Kensington, and only the most distant houses here have survived.

Holland Park Avenue, 1908. This was the north side of Holland Park Avenue, where the arrival of the new motorway proved equally destructive. Although four of the shops on the right still stand, almost everything shown here has disappeared, including the Royal Hotel with its unusual tower. Beyond were the twin towers of the Franco-British Exhibition, held at the new White City in 1908. This was the brainchild of Imre Kiralfy of Earls Court Exhibition fame.

Norland Road, c. 1920. This is one of London's lost street markets, seen here some fifty years before many of its shops were swept away for motorway construction and housing redevelopment. The road straddles the boundary with Hammersmith (left), while on the Kensington side we can see beyond the few shops that still stand up to the Stewart Arms, since rebuilt, on the Royal Crescent Mews corner. Unusually, some of the domestic properties hereabouts had stone frontages, including the shops on the left. The tower blocks of the Edward Woods housing estate dominate the scene here now, and the road is a pedestrian precinct.

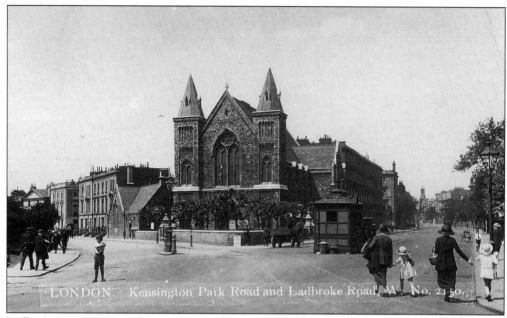

Ladbroke Road (left) and Kensington Park Road (right), 1920. While some Kensington views have changed out of all recognition during the past seventy five years, others only show superficial alterations, as here, where even the old wooden cab driver's shelter remains in place. The church is Kensington Temple, once known as Horbury Congregational chapel. It was built in 1848 with Kentish Rag stonework which was looking rather sooty after many decades exposure to what was once a very smoky London atmosphere. Traffic conditions have changed, however; the boy on the left would not survive for long if he stood there today.

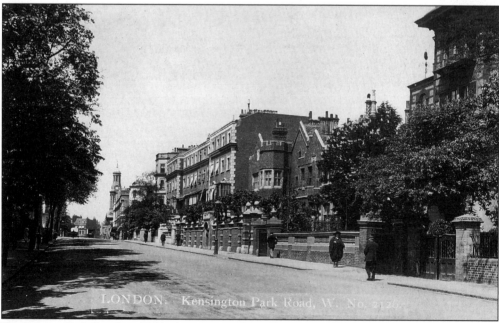

Kensington Park Road, c. 1920, showing on the right some of the fine houses that have been replaced by more up-to-date flats.

Seven

North Kensington

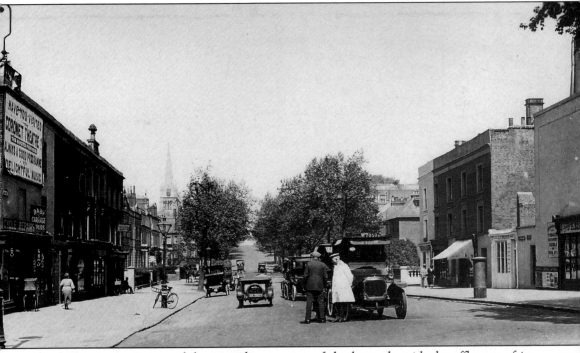

North Kensington is one of the most diverse areas of the borough, with the affluence of its southern part in close proximity to poor housing conditions and post-war urban renewal. Its multi-cultural communities have given North Kensington a special vibrancy, with rip-roaring weekend markets and the annual carnival, as colourful a spectacle as can be found anywhere. The backbone of northern Kensington is Ladbroke Grove, a broad boulevard running north-westward from leafy Holland Park Avenue before climbing its switchback hill where grandiose squares, crescents and terraces were laid out during the middle of the last century. From there, Ladbroke Grove continues towards the borough boundary, where it peters out beyond the Great Western Railway lines, and the canal at Harrow Road. The photograph from around 1920 was taken from Holland Park Avenue, with the tower of St John's church visible at the top of the hill. The church was built in 1844 on the site of the grandstand of the ill-fated Hippodrome racecourse, which only lasted from 1837 to 1841. The premises on the left included number $9\frac{1}{2}$ Ladbroke Grove, where William Wright, Bath chair proprietor had his abode. The shops have been replaced by a neo-Georgian block in recent years.

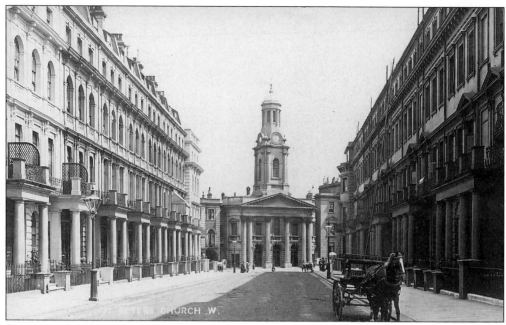

St Peter's church, Kensington Park Road, from Stanley Gardens, *c.* 1906. This fine classical townscape, dating from 1852, was designed by Thomas Allom for his development of the Ladbroke Estate.

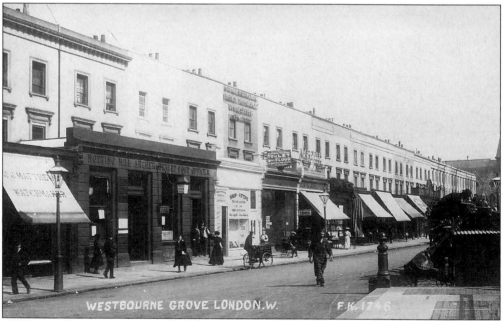

Westbourne Grove from Archer Street, *c.* 1904. Archer Street is another of the names that disappeared during the late 1930s, the stretch westward to Kensington Park Road becoming part of Westbourne Grove. Here we see the post office, then called 'Notting Hill, Archer Street', and adjoining shops including that of William Mardell. His stock included antiques and the shop was a forerunner of many such establishments that now flourish here. The road takes its name from the Westbourne, an underground stream whose waters flow into the Serpentine.

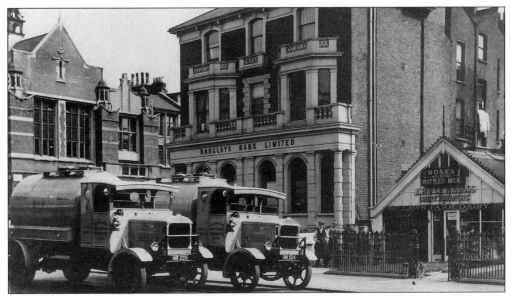

J. Rose & Sons dairy, Lancaster Road, *c.* 1927. This company provided a 'glass lined milk tank service' from its Wiltshire farm to the Lancaster Road shop with this pair of Maudslay motor tankers. The style of the shop building hints at the business of its former occupant, Duncan McKeller, nurseryman. Its neighbour, Barclay's Bank, can still be seen at the Ladbroke Grove corner, albeit in a modern building. North Kensington library can be seen in the background. Dating from 1891 to 1894, it was Kensington's first purpose built public library. (Ron Elam Collection).

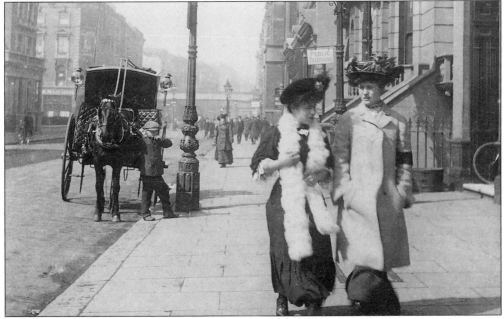

Edwardian ladies in their finery, Ladbroke Grove, *c.* 1908. This was an example of an informal photograph taken by an itinerant street photographer, the subject usually being caught unawares as here. The scene was outside the Elgin Tavern, and shows a small boy minding a Hansom cab, doubtless while its owner finds refreshment within the Elgin.

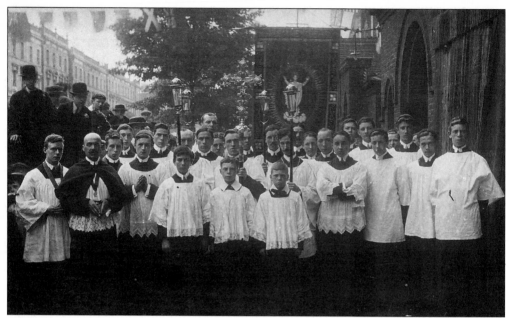

Choristers at St Columb's church, Lancaster Road, c. 1910. The church was built from 1900 to 1901, and from 1951 was known as the Serbian Orthodox church of St Sava. From its earliest days, the church staged religious street processions which filled the local streets with spectators in the manner of the latterday Notting Hill Carnival.

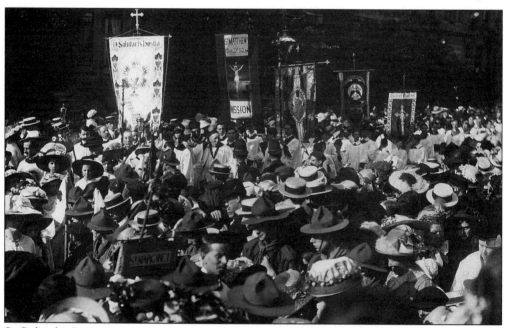

St Columb's Procession, 1913. Everyone was in their Sunday best, which for the ladies included some splendid hats and meant neat straw boaters for the men. A number of boy scouts were in attendance, with a pair of policemen who appear overwhelmed by the throng.

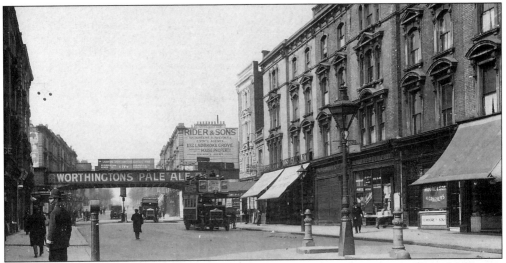

Ladbroke Grove from Lancaster Road, c. 1920. This group of shops were established following the arrival on 13 June 1864 of the Ladbroke Grove station of the Hammersmith and City Railway, now part of the Metropolitan line. The station was originally called 'Notting Hill', then 'Notting Hill & Ladbroke Grove', and we see it here having just acquired yet another new name, 'Ladbroke Grove (North Kensington)'. It is now merely 'Ladbroke Grove'. The railway bridge was joined by a new, larger neighbour during the 1960s, when the elevated Westway was built, removing some of the distant shops. To the right of the No. 7 bus was the tiny frontage of Ladbroke Hall, where there was dancing three nights a week in a hall that could be hired for weddings and amateur dramatics. A public fire alarm post can be seen in the foreground, and the policeman appears to have seen something suspicious in Lancaster Road.

Ladbroke Grove from the station, c. 1910. Only five shops in this row survived following the arrival of Westway, whose viaduct runs over the site of the foreground buildings. Note the tiny premises, complete with miniature gable of Gearing & Sons, art photographers, and to the right, resplendent with stained glass windows, Rider & Sons' North Kensington estate offices. Property then on offer included a leasehold house and shop in Walmer Road for £35 per annum!

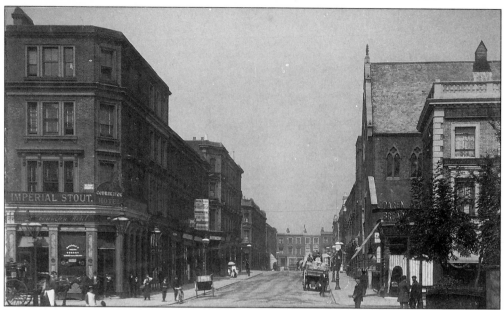

Kensington Park Road by Elgin Crescent, *c.* 1906. This is another street whose buildings have altered little during the past ninety years. The Peniel chapel can still be seen on the right, but the Codrington Hotel's old premises on the opposite corner are now a laundrette.

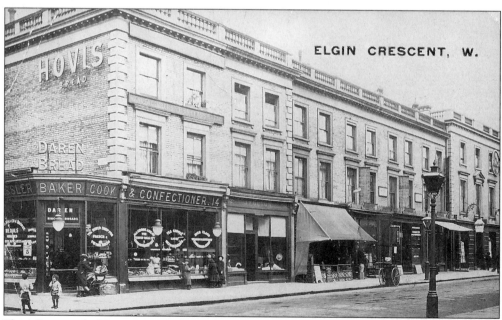

Elgin Crescent by Keningston Park Road, *c.* 1906. This Victorian terrace still stands, but many of the old domestic stores have been replaced by the trendier overflow from the neighbouring Portobello Road antique market.

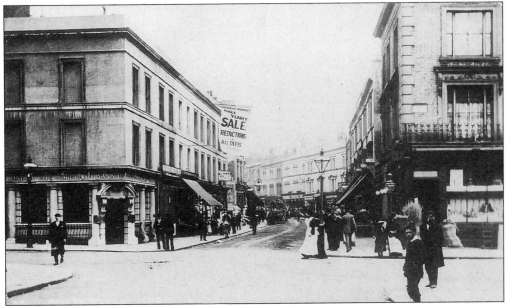

Portobello Road from Elgin Crescent, *c.* 1908. Portobello Road evolved from Portobello Lane, a rustic byway that led to Portobello Farm. Increasing urbanisation from the 1860s turned Portobello Road into a shopping street, and there were market stalls to supplement to shops. While the traditional 'fruit and veg' maintained a stronghold in the central part of the market, the southern end of Portobello Road was colonised by the antique trade from the 1940s,which led to the establishment of the world famous antique market. The photograph shows part of what is now the antique section, then with its original domestic stores. These were later converted into the characteristic antiques arcades, with each shop containing an incredible number of dealers working in cramped but fascinating chaos.

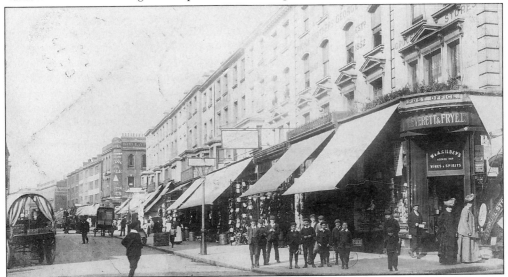

Portobello Road, *c.* 1905. This is part of the 'fruit and veg' section of the road, with a branch of Leverett & Frye (once a familiar high street name) on the Colville Terrace corner. The shop windows were all crammed with merchandise, as was usual during Edwardian times. The Colville Hotel is seen on the corner in the distance.

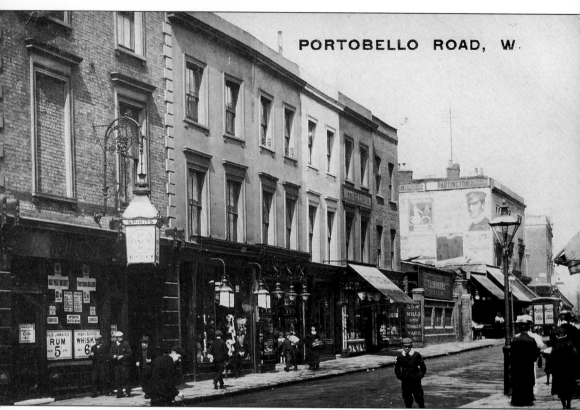

Portobello Road from Colville Terrace, c. 1906. The Duke of Wellington pub is seen on the left, with a short terrace of shops that led to T.H. Saunder's saw mills and timber yard. This was shortly to be replaced by what was then an innovative building, the Electric Cinema, erected in 1910-11 to designs by G.S. Valentin. This still stands and is one of the earliest purpose built cinemas in Britain, having been restored in 1990. When first built, its bright electric lighting would have been a dramatic sight in the dimly gas-lit market. The photograph shows some of the colourful advertising posters of the period on the end wall overlooking Saunder's timber yard; with the gentleman on the Wills Gold Flake Cigarette poster appearing to glance admiringly at the neighbouring lady on her Rudge Whitworth bicycle. The pub displays the prices of spirits using an archaic measurement, the 'quartern', a quarter of a pint. Old Jamaica Rum was available at 5d (about 2p) per quartern, and Whisky 6d (2½p) for a similar measure.

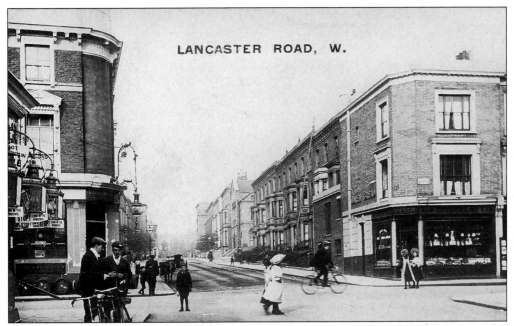

Lancaster Road, *c*. 1906. This is the point where Lancaster Road crosses Portobello Road, further along are Peters' bakery shop on the right, and Basing Street. The shop on the far left seemed especially anxious to attract the passer-by with beautiful hanging lamps and signs.

Lancaster Road, 19 March 1915. As North Kensington shed its rural appearance during the building boom of the 1870s, standards were not always of the highest quality, as was revealed when high winds caused these houses to lose their parapets. A quartet of policemen stand guard over the rubble, which destroyed the street railings as it fell. These houses still stand, however, looking none the worse for their earlier ordeal.

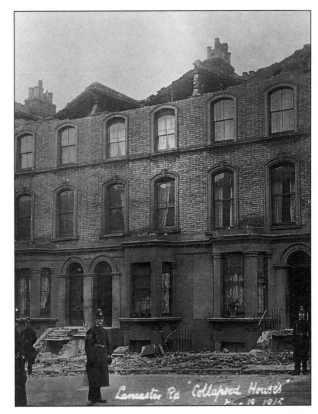

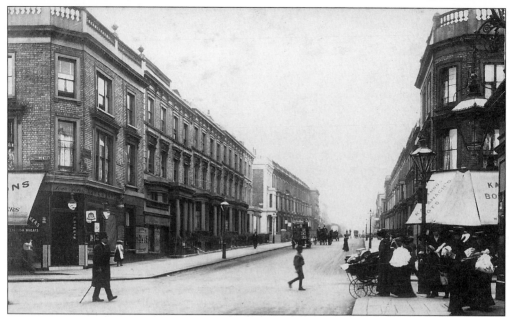

Cornwall Road from Portobello Road, *c.* 1906. This is one of the densely built-up roads that were developed during the 1870s, when speculative builders utilised their land to the full, with little room left for the trees and gardens that give much of Kensington its special appeal. Cornwall Road was renamed during the 1930s; it is now Westbourne Park Road.

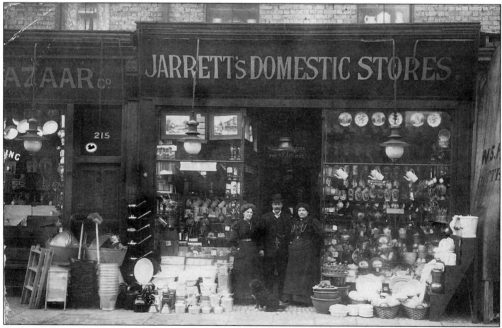

William Jarrett's Domestic Stores, at 217 Portobello Road, was another emporium that catered for the household needs of this populous quarter. The hardware on offer included an array of china plates and ornaments that would no doubt be very acceptable stock for today's dealers in the Portobello antique arcades. To the left was the National Bazaar, with a windowful of goods; 'everything 6½d', (about 3p). A view from around 1906.

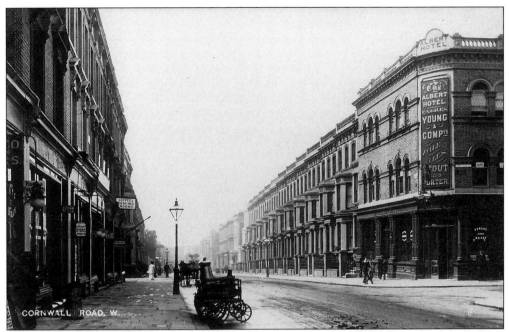

Cornwall Road, (Westbourne Park Road), c. 1906. The Albert Hotel on the All Saints Road corner has been replaced by shops, and the site of the shopping parade to the left is now occupied by Clydesdale House, a modern block of flats.

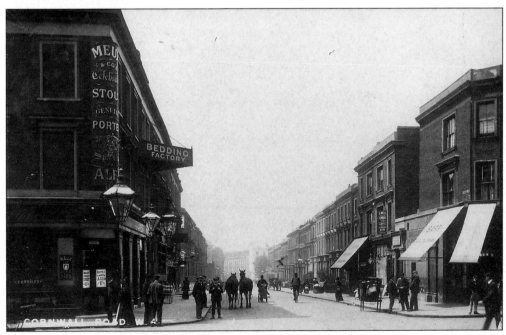

Cornwall Road, (Westbourne Park Road), c. 1906. The Warwick Castle on the Portobello Road corner tempts the passer by with 'Bitter & Burton Ales' at 1½d (less than 1p) per half pint, with Bovril also available. The opposite corner was then occupied by James Barr, oil and colourman, and the tiny Cornwall Hall can be seen behind his shop.

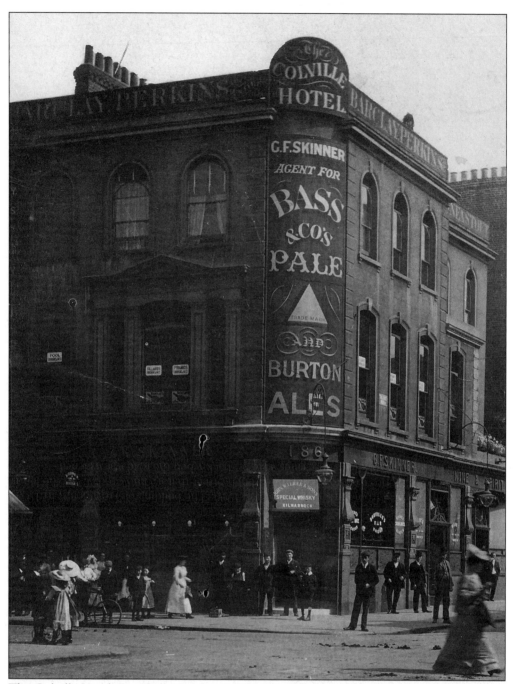

The Colville Hotel, Portobello Road, c. 1906. Corner pubs such as this proliferated in these busy streets, and many of them have survived to quench the thirsts of Portobello Road's latterday shoppers. Here, the landlord, George Skinner provided billiards, pool and pyramids in the roomy first floor area. The flamboyant lettering was typical of Victorian and Edwardian pubs, but the outside lamps were unusually modest. In the foreground, a full skirted lady illustrates one of the hazards of an era of horse drawn traffic, as she picks her way through the copious horse droppings in the road. Talbot Road is on the right.

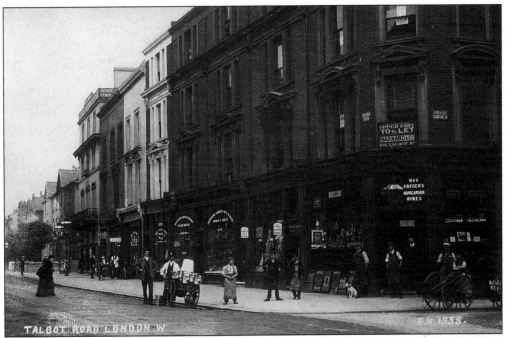

Talbot Road, c. 1905. This road dates from 1857, its name taken from that of local landowners. The view was taken from Powis Square and shows the corner shop of Mainprice & Lord, the wine merchants, as their staff take a break from their labours, together with a milkman and his handcart. Clients would have brought their own jugs to fill from a tap in the milkman's churn.

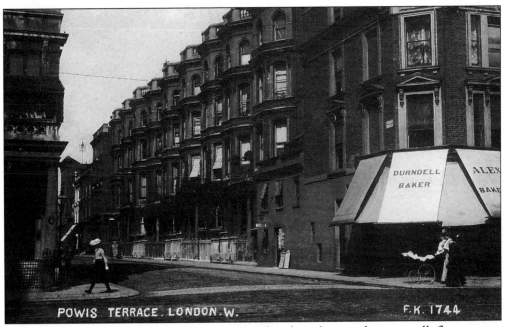

Powis Terrace from Talbot Road, c. 1905. The deep bay-windows on all floors are a distinguishing feature of houses in this neighbourhood. Note the tiny newsagent's shop tucked away behind the grander premises of Alex Durndell, the baker.

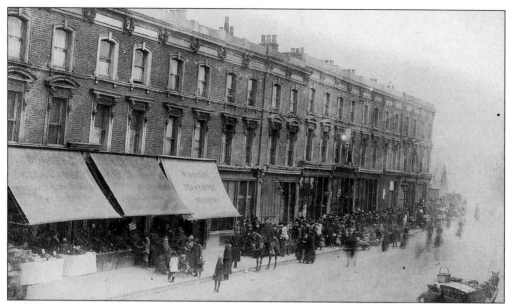

Golborne Road, *c.* 1917. Hardship was no stranger to the sometimes grim streets of North Kensington, this being particularly so during the First World War, when there was such a shortage of potatoes that queues like this built up at the premises of those greengrocers fortunate enough to secure a supply. Thomas Burgess's shop was in that happy position here, sales being strictly rationed and 'no children served', with police on hand to control the crowd which stretched out of sight beyond the railway bridge. The street lamps were partly masked in the blackout conditions of the war, when air raids from German Zeppelins were a constant threat.

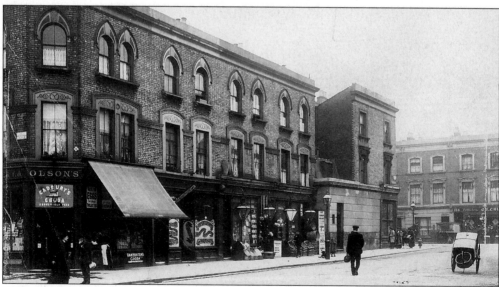

Golborne Road by Hazelwood Crescent, *c.* 1906. The modern Holmefield House flats have replaced this shopping parade which included the Golborne Haircutting & Shaving Saloon, with its decorative but opaque windows. The whole of this locality is now dominated by one of London's most dramatic residential tower blocks, the thirty-storey Trellick Tower, built in 1972 as part of a major slum clearance. Kensal Road is visible to the right.

118

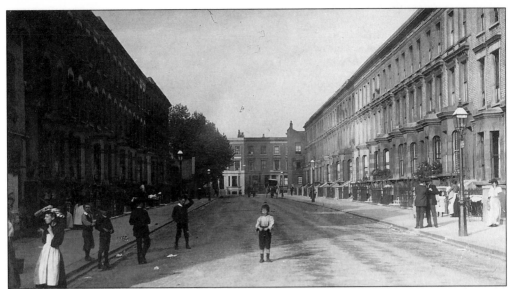

Faraday Road, *c.* 1908. A busy scene in a typical North Kensington road, built around 1868, and named after Michael Faraday, the experimental physician and founder of the science of electro magnetism, who died in 1867. The view looks north-east from Portobello Road, but no trace will be found of it today following the development of a new residential neighbourhood, Wornington Green, which ignored the old street patterns.

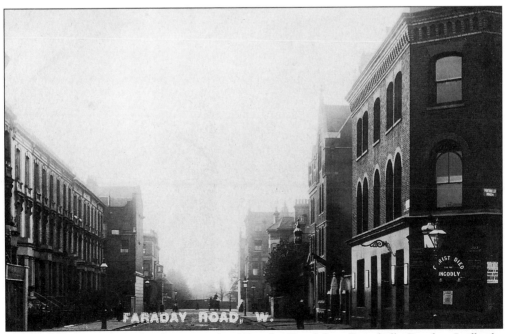

Faraday Road, *c.* 1908. The short stretch of Faraday Road from Portobello Road to Ladbroke Grove still exists, although most of the old buildings, including the fire station have been replaced. The Mission Hall on the right still stands, but its ground floor is now a betting shop.

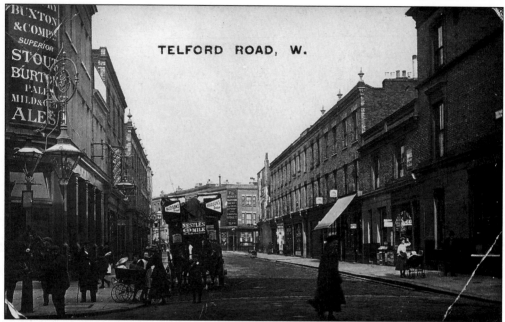

Telford Road from Ladbroke Grove, c. 1906. This road, of 1868 vintage, was named after Thomas Telford, the Scottish engineer. A horse bus awaits its driver, who was probably seeking refreshment at the Eagle pub (left), or the adjoining Eagle Coffee and Dining Rooms. Most of Telford Road has been rebuilt including the shops on the right and those on the left beyond Lionel Mews. Portobello Road is in the distance, its old buildings having given way to the new Wornington Green estate.

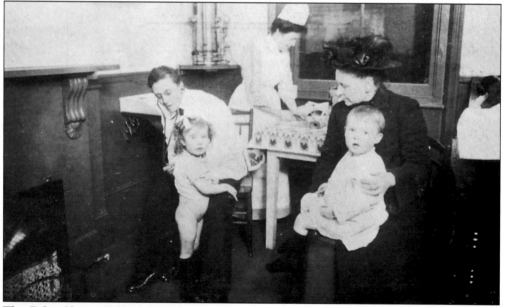

The Baby Clinic, Telford Road, 1911. The clinic, at 12 Telford Road, was opened on 27 November 1911, by James Ramsay MacDonald MP, who was later to serve three times as Britain's Prime Minister. The North Kensington Women's Welfare Centre also occupied this building.

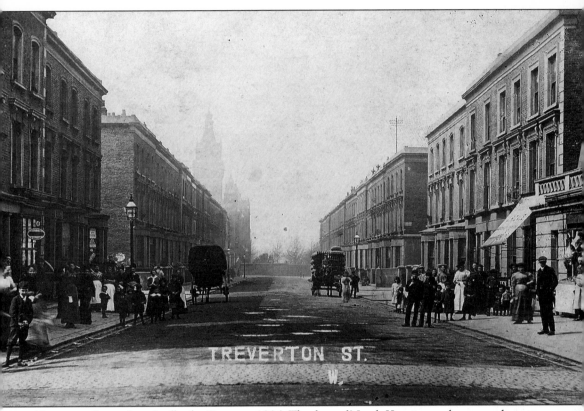

Treverton Street from Ladbroke Grove, *c.* 1906. The face of North Kensington began to change from the 1950s as much as the old worn out property began to be replaced by bright modern housing. This happened here at Treverton Street and Treverton Tower, a multi-storey block of flats superseded these old terraces. What shops there were here were of the most rudimentary kind, some being conversions of ground floor living rooms, as seen on the left, where J. Lowe, the publisher of this photograph had his newsagents shop. The butcher's shop on the right looks most uninviting with meat hanging outside in the sun, but this was quite usual in the days before electric refrigeration. Long vanished side roads seen here are Bransford Street to the right, and Raymede Street to the left, with Exmoor Street and the towers of St Charles Hospital in the far distance.

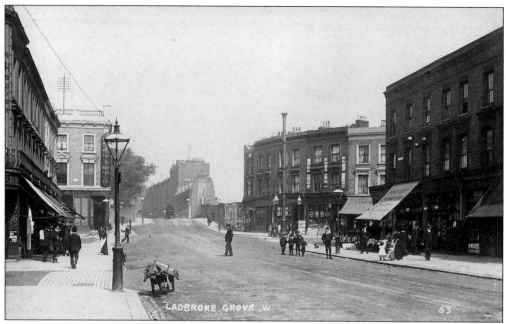

Ladbroke Grove by Treverton Street, *c.* 1910. The broad expanse of Ladbroke Grove narrows as it crosses the Great Western Railway bridge seen here, with Wornington Road on the right. Treverton Street is on the far left, and further along is Barlby Road with the Admiral Blake pub on its corner, jutting out as the road narrows. The shops on the right have been replaced by part of the Murchison Road estate.

Ladbroke Grove between the bridges of the Great Western Railway and the Grand Junction Canal, *c.* 1908. Western, Victoria and Ladbroke Dwellings, solid Victorian flats at the less fashionable end of Ladbroke Grove, have given way to the Grand Union Centre, a complex of modern workshops, studios and offices.

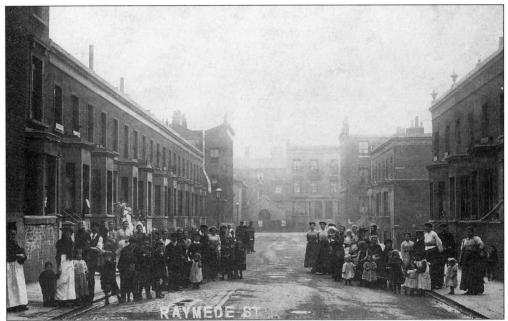

Raymede Street, *c.* 1906. Redevelopment has left no trace of this once populous street, only the name of the flats subsequently built here, Raymede Tower, preserves the memory. Rackham Street, seen in the distance with its Mission Hall, suffered a similar fate, but Hewer Street (right) still exists. Life was sometimes hard in this corner of Kensington but the arrival of a photographer would usually prove to be a welcome diversion for local folk who would, as here, turn out in force to get into the picture.

Hewer Street, *c.* 1910. This was the Royal Sanitary Laundary's premises, with two of their delivery carts. Remarkably, these buildings still stand, having survived the extensive rebuilding of much of the surrounding area.

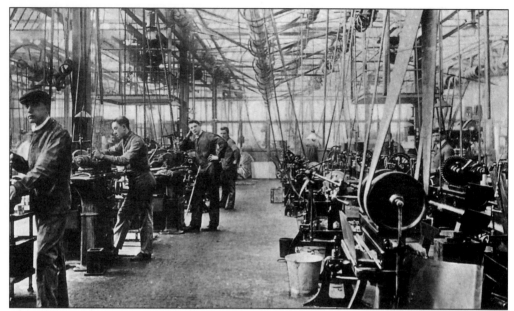

The Clement Talbot Motor Works, *c.* 1906. Among the industries that grew up in the vicinity of the Grand Junction Canal and the Great Western Railway was the first purpose built English car factory, the Clement Talbot Motor Works, dating from 1903. The machine shop seen here was situated behind an impressive frontage, and the entrance hall that can still be seen in Barlby Road. This is currently being renovated, and the old machine shop site is being used for a new housing estate.

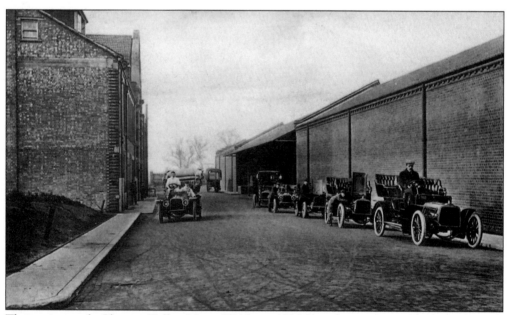

The testing track, Clement Talbot Motor Works, *c.* 1906. Brand new cars are being put through their paces before being licensed to run on public roads.

Barlby Road, c. 1910. At the turn of the century, this part of North Kensington contained a great deal of open land, much of it in the form of sports fields, but it was not long before the developers moved in to create a new estate of pleasant two-storey houses, their style common in much of London, but quite rare in Kensington. Kensal Green Gasworks and the Clement Talbot Motor Works are seen in the distance to the right.

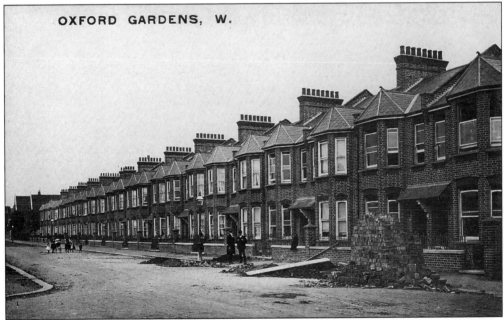

Oxford Gardens, c. 1907. Brand new houses on the St Quintin Estate, with builders' rubble and unmade roads still in evidence. The houses were built in the last part of rural Kensington to be developed, by Messrs Daley & Franklin. At their estate office in Wallingford Avenue, a new house could be bought for £425, or rented from £36 per annum. In 1908, the proximity of the estate to the Franco-British Exhibition at the new White City was used as a selling point.

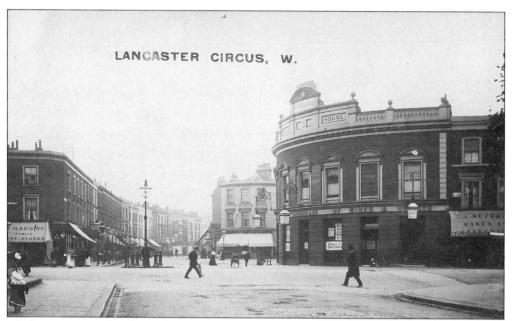

Lancaster Circus from Silchester Road, *c.* 1906. Post-war municipal housing developments have obliterated the old street pattern at this once busy locality where Lancaster, Silchester, Clarendon and Walmer Roads met. The curved frontage of the Lancaster Arms is on the right, and the distance view is of Clarendon Road with a heavy concentration of street lamps in front of the shops.

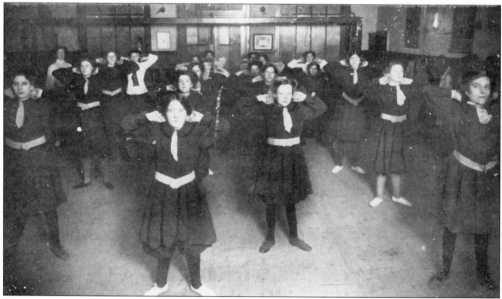

The Latymer Road Mission, Blechynden Street, *c.* 1912. This was a rather deprived area of North Kensington, but at the Latymer Road Mission, the West London branch of the Ragged School Union, there would always be a free meal or a jug of cocoa for a needy child. Physical fitness was important too, as these young ladies show us as they go through their exercises in the mission's gymnasium.

126

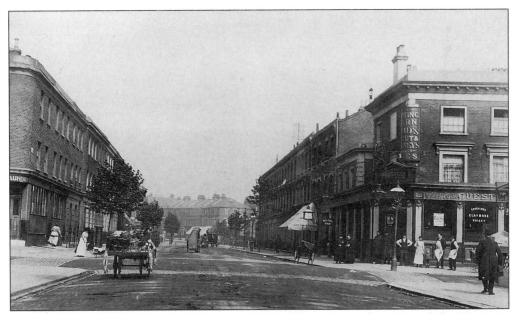

Bramley Road by Silchester Road, *c.* 1906. The building during the 1960s of the Westway, 'motorway in the sky', altered the face of North Kensington for ever as it ploughed on through old neighbourhoods. The viaduct now runs high above the sites of these houses and the Notting Barns pub. St Helens Gardens are visible in the distance.

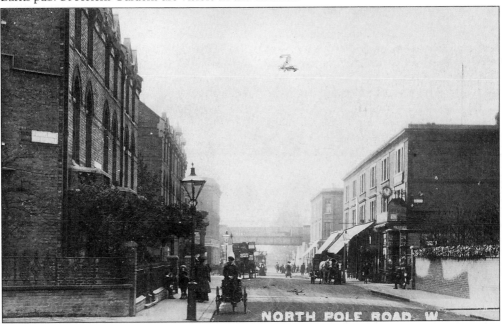

North Pole Road from St Quintin Avenue, *c.* 1906. This is another part of the boundary between Hammersmith and Kensington, with the distant bridge marking the position of one of London's 'lost' stations, 'St Quintin Park and Wormwood Scrubs', on the West London Railway. The station opened on 1 November 1893, and its official closure on 1 December 1940 was preceded by total destruction on 3 October 1940, when its wooden buildings and platforms were struck by incendiary bombs.

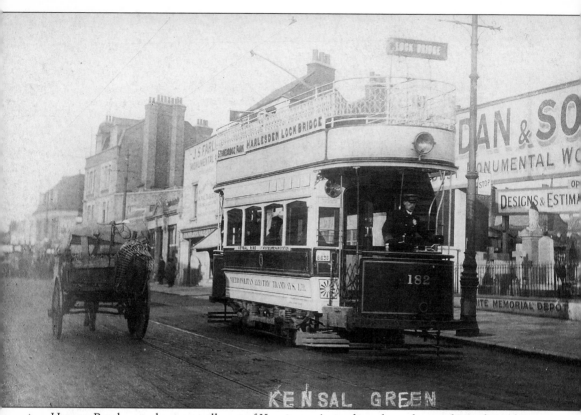

Harrow Road runs along a small part of Kensington's northern boundary and was the only part of the borough in which electric trams, and later, trolley-buses ran. This view from around 1906, was taken opposite Kensal Green Cemetery, and shows a Metropolitan Electric Tramway car en route from Stonebridge Park to Lock Bridge in Paddington.